IMAGES
of America

ATLANTA AND THE CIVIL RIGHTS MOVEMENT 1944–1968

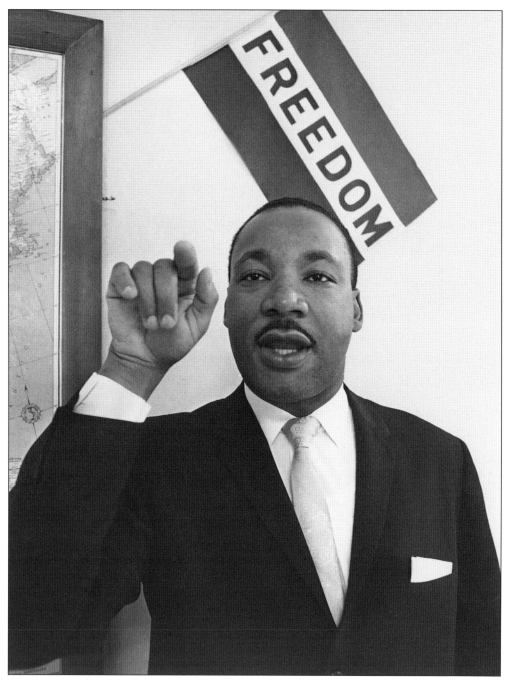

Dr. Martin Luther King Jr. is pictured speaking to a journalist in his Auburn Avenue office on the plans for the Poor People's Campaign of 1968. (Associated Press.)

ON THE COVER: Following Sunday service on December 16, 1963, more than 2,500 people demonstrated their support for equal employment, quality housing, and the integration of public schools by participating in a mass rally at Hurt Park led by Dr. Martin Luther King Jr. (Associated Press.)

IMAGES
of America

ATLANTA AND THE CIVIL RIGHTS MOVEMENT 1944–1968

Karcheik Sims-Alvarado, PhD

ARCADIA
PUBLISHING

Published by Arcadia Publishing
Charleston, South Carolina

Printed in the United States of America

Library of Congress Control Number: 2016953988

For all general information, please contact Arcadia Publishing:
Telephone 843-853-2070
Fax 843-853-0044
E-mail sales@arcadiapublishing.com
For customer service and orders:
Toll-Free 1-888-313-2665

Visit us on the Internet at www.arcadiapublishing.com

To the history makers, Mildred English-Sims, Aaron Myrick,
William and Myrtice English, William and Susan Harrison-Myrick,
Dr. Henry and Clarissa Harrison, and Elizabeth Hammond.
Finally, to my ever-supportive husband, Joel, and talented son,
Nation, who loves to snuggle and listen to stories of the past.

CONTENTS

ACKNOWLEDGMENTS

I am grateful to so many people who have assisted me in the development of this book. First, I would like to acknowledge the ancestors for their many sacrifices and achievements. I am who I am because of you. Next, I would like to thank my mother, Mildred English-Sims, who loves art, history, and all things beautiful. Your determination to defy Jim Crow laws and customs led to my creation.

I would also like to acknowledge those who have assisted in my professional development. Dr. Jacqueline Rouse, your question, "What is a Movement?" began my journey of learning and teaching the organizational structure of the long civil rights movement. A team of female scholars have also groomed and opened doors for me: Drs. Carole Merritt, Janice Sumler-Edmond, Josephine Bradley, Vicki Crawford, Roslyn Pope, and Yvonne Newsome.

My experience of serving as a fellow with the National Endowment for Humanities: African-American Struggles for Freedom and Civil Rights Institute at Harvard University under the directorship of Drs. Henry Lewis Gates, Waldo Martin, and Patricia Sullivan, ignited the spark to document Atlanta's contribution to the long civil rights movement.

My experience of working with George C. Wolfe and Doug Shipman on the development of the exhibition at the National Center for Civil and Human Rights helped me to realize the importance of creating a "portable exhibition" in book form for the public. Also, being inspired by the volume of books written by my friend, Herman "Skip" Mason, I decided to join the Arcadia Publishing family by writing *Atlanta and the Civil Rights Movement: 1944–1968*.

The majority of the images for this project were made possible through the generous support of the Associated Press. Tricia Gesner: I cannot thank you enough. I am also grateful to the staff of the Library of Congress, The Herndon Home, Auburn Avenue Research Library Archives, and the Georgia State University Archives. A special thank-you to John Wright, Teniade Broughton, La'Neice Littleton, my sisters and brothers, and many friends.

I cannot thank enough my husband, Joel Alvarado. You are my greatest champion. Nation, you are my sun, moon, and stars.

Unless otherwise noted, all images are courtesy of the Associated Press.

INTRODUCTION

This book is a pictorial history of the modern civil rights movement in Atlanta, Georgia, from 1944 to 1968, ending with the death of Dr. Martin Luther King Jr. in Memphis, Tennessee. From seeking power through the ballot to calling for Black Power, Atlanta has been at the epicenter of social change. Men and women like John Wesley Dobbs, A.T. Walden, Constance Baker Motley, Bayard Rustin, Ella Baker, Dr. Martin Luther King Jr., Coretta Scott King, C.T. Vivian, and John Lewis sought to provide black citizens of Atlanta a pathway towards greater personal, political, and economic autonomy.

This is a history about ordinary people willing themselves to act courageously to achieve extraordinary outcomes. During the mid-20th century, the world as African Americans knew it changed dramatically with the passage of landmark federal legislation and legal victories before the US Supreme Court. As Ella Baker proclaimed, this movement was "bigger than a hamburger," for it allowed the United States to move closer toward becoming a more perfect union.

As early as World War II, black Atlantans organized in a concerted effort toward achieving civil and human rights. Throughout the 1940s, African Americans demonstrated their mobilization strength during various voting registration campaigns. Beginning in 1944, more than 5,000 black Atlantans arrived at the Fulton County Courthouse on May 3–8 to register in large numbers, hoping to participate in the forthcoming primary election. Although black voters were denied the opportunity to vote in the July 4 primary election, two years later, they did score a victory by electing a Congressional candidate of their choice, Helen Douglas Mankin. With the Supreme Court declaring that African Americans had the right to participate in Georgia primary elections in *King v. Chapman*, a registration campaign led by black leaders in Atlanta increased from 7,000 to more than 21,000 in 1948, positioning black business and civil rights leaders to pressure Atlanta mayor William Hartsfield to hire eight black police officers. Following the hiring of the officers, black Atlantans showed their support for Hartsfield by re-electing him in 1949. This "give-and-take" relationship established between members of the white elite and black community continued over the next decade, but it would be challenged by white opposition and hate groups that recognized the political strength of black Atlantans.

In January 1957, less than two weeks after calling off the Montgomery bus boycott, Dr. Martin Luther King Jr. returned to Atlanta and established the Southern Christian Leadership Conference (SCLC) with the assistance of Bayard Rustin and Ella Baker. During the same month, a group of black ministers established the Triple L movement (Law, Love, and Liberation) to end racial segregation on Atlanta city buses. Leaders of the boycott were Reverends William Holmes Borders, Martin Luther King Sr., R.B. Shorts, R. Joseph Johnson, Howard T. Bussey, and Ray Williams. Their actions, based upon the 1956 Supreme Court case *Browder v. Gayle* declaring segregation on buses unconstitutional, led to the US District Court Northern District of Georgia ruling against the segregation of buses in Atlanta in 1959. During the same year, Mayor Hartsfield pressured the library board of trustees to change its policy to allow for the immediate integration of its libraries. On May 22, 1959, Irene Dobbs Jackson became the first black recipient of a library card from the Central Atlanta Library.

On February 1, 1960, the nation learned of four African-American students from the North Carolina Agricultural and Technical State University in Greensboro, North Carolina, who sat down at a "whites-only" lunch counter at a local Woolworth's department store. The sit-in demonstration caught the attention of several Atlanta University Center (AUC) students. Collectively, the students formed a local civil rights organization named the Committee on Appeal for Human Rights (COAHR). Before the formation of the organization, the students were asked by their respective college presidents to articulate their grievances in a manifesto. Roslyn Pope, SGA president of Spelman College, penned "An Appeal for Human Rights," declaring, "We do not intend to wait placidly for those rights, which are already legally and morally ours to be meted out to us one at a time. Today's youth will not sit by submissively while being denied all of the rights, privileges, and joys of life." The "Appeal," published in various Atlanta newspapers, ignited the Atlanta Student Movement. The following week, AUC students began what became a series of direct-action demonstrations against local businesses to integrate public accommodations in the city.

Recognizing the importance of youth activism to the movement was Ella Baker of SCLC, who was fundamental to forming the Student Nonviolent Coordinating Committee (SNCC). The organization, comprised of white and black college-age activists, established its national headquarters in Atlanta in 1960 and expanded its efforts beyond the integration of public facilities by registering blacks in Mississippi and Alabama, where voter suppression was greatest. Over the decade, the two national civil rights organizations, SCLC and SNCC, expanded their efforts beyond Atlanta to push for passage of the Civil Rights Act of 1964 and the Voting Rights Act of 1965. After securing legislative victories, both organizations recognized that the battle for human rights was far from over. From 1966 to 1968, SCLC and SNCC advocated for economic justice reform and against the Vietnam War. Moving beyond the utopian rhetoric of racial harmony, both organizations and their leaders were defined as "radical" and "militant."

This book ends with the death of Dr. Martin Luther King Jr. and the city's response to the loss of the world's greatest civil rights leader.

Fortunately, the actions of many leaders and their supporters were documented by numerous photographers, both professional and lay, who understood that history was unfolding before their eyes and needed to be captured for posterity. It is the faces of the movement, the voices of the movement, the strategists of the movement, and the photographers of the movement that we honor in the pages of this book.

One

ATLANTA'S BLACK
VOTING POWER

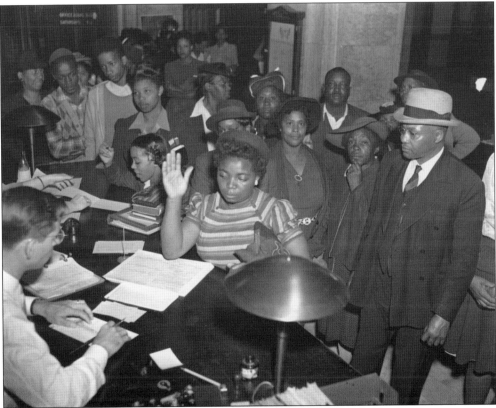

A watershed moment in the long struggle for justice and equality was the US Supreme Court decision in *Smith v. Allwright*, declaring it unconstitutional to deny a citizen, regardless of race, from participating in primary elections, often referred to as "white primaries." In response to the *Smith* decision, thousands of African Americans appeared at the Fulton County Courthouse in Atlanta to register to vote in the July 4, 1944, Georgia Democratic primary.

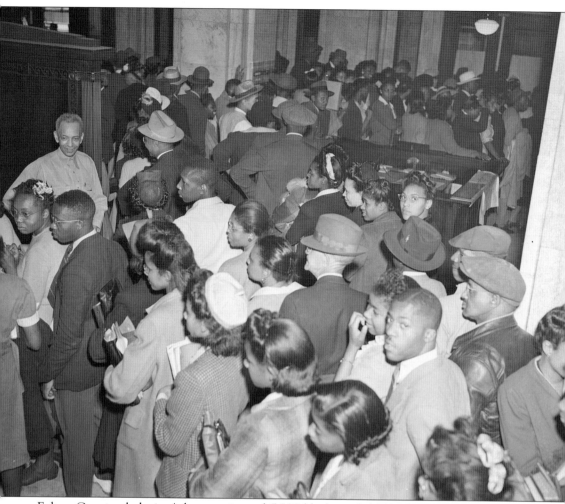

Fulton County clerks in Atlanta estimated 5,000 blacks and 6,000 whites registered to vote between May 3 and May 5, 1944. While registration efforts were successful, blacks were denied the opportunity to vote during the succeeding Democratic primary. Poll officials claimed the names of black voters were not on the registration list.

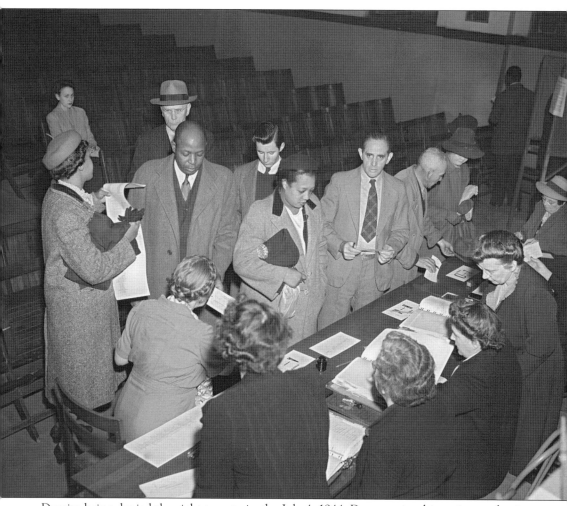

Despite being denied the right to vote in the July 4, 1944, Democratic white primary election, African Americans did participate in the November 7 general election. Here, blacks and whites are seen voting at a fifth-ward precinct at the Forrest Avenue School.

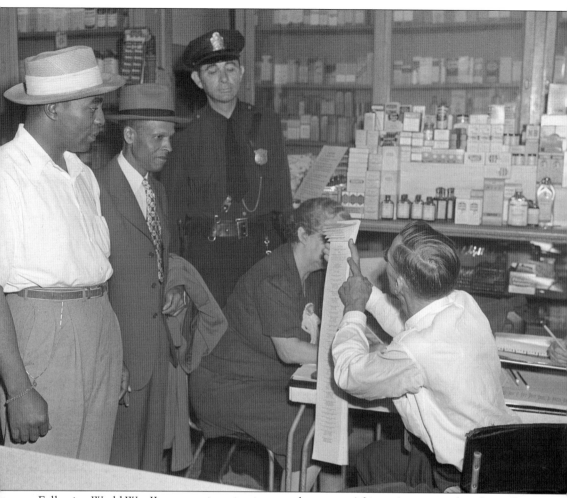

Following World War II, voter registration increased amongst African Americans, but their effort to successfully participate in the primary election was met with opposition from white poll officials. Several Atlantans hoped to exercise the franchise by testing the *Smith* decision. The testers included A.T. Walden, attorney; Clarence A. Bacote, history professor at Atlanta University; Eugene M. Martin, vice president of Atlanta Life; and V.H. Hodges, assistant publisher of the *Atlanta Daily World*. All were denied the opportunity to vote. The following year, African Americans tested the *Smith* decision again. Pictured are Lewis K. McGuire (far left), World War II veteran, and S.M. Lewis (second from left), a physician who attempted to vote in the city's Democratic primary on September 5, 1945. Both men were turned away by poll official W.R. Owens, sitting. Standing is police officer Roy Wall.

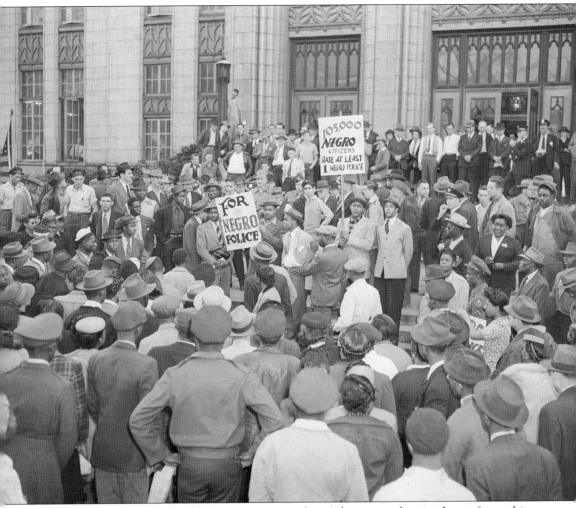

As the number of registered black voters increased in Atlanta, racial intimidation from white terror groups and police officers ensued. In March 1946, the United Negro Veterans and Women's Auxiliary organized 200 demonstrators to march against police brutality and demand the hiring of black police officers. World War II veterans and supporters carried placards bearing the words, "105,000 Negro Citizens Rate at Least 1 Negro Police." Before assembling onto the steps of the Atlanta City Hall, protesters circled the building twice shouting, "Square Deal for the Negro." White city officials and police officers stood at the periphery of the crowd as black demonstrators listened to speakers.

In April 1946, the US Supreme Court ruling in *King v. Chapman* struck down the Georgia Democratic white primary. In response, blacks mobilized to increase the number of registered voters in Atlanta. On May 4, the black electorate expanded from less than 7,000 to more than 21,000. The 1946 voter registration campaign was organized through the concerted efforts of a cohort of civic and community leaders including A.T. Waldon (left), attorney and cofounder of the Fulton County Citizens Democratic (FCCD) Club, and John Wesley Dobbs (below), grandmaster of the Prince Hall Masons of Georgia and founder of the Atlanta Civic and Political League.

Two more leaders of the voter mobilization were Dr. Clarence A. Bacote (right), historian and leader of the All-Citizens Registration Committee, and C.A. Scott (below), editor of the *Atlanta Daily World* and co-founder of the FCCD Club. (Below, courtesy of Maryam Jordan.)

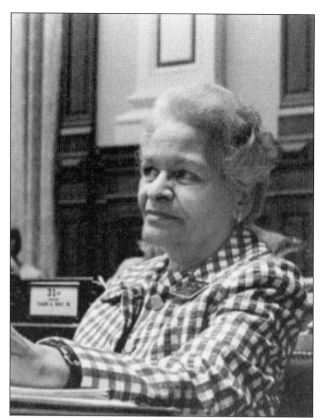

The efforts of women to organize voters during the 1946 registration campaign cannot be ignored. Pictured is Grace Towns Hamilton, executive director of the Atlanta Urban League. She later became the first African American woman elected to the Georgia General Assembly, serving from 1965 to 1985.

One of the greatest grassroots leaders and mobilizers of the black female vote was Ruby Parks Blackburn, a beautician and organizer of the To Improve Committee (TIC) Club, the Atlanta Cultural League and Training Center, and the Negro League of Women Voters. Blackburn is pictured here at far right with National Council of Negro Women founder and president Mary McLeod Bethune (seated). (Courtesy of Auburn Avenue Research Library.)

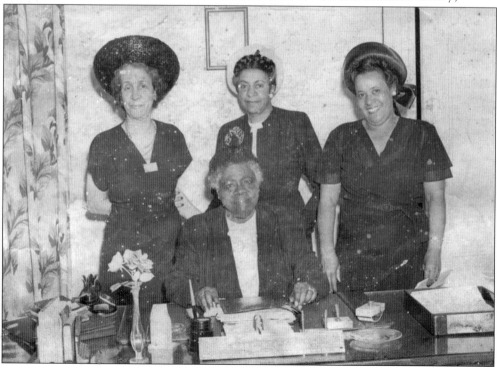

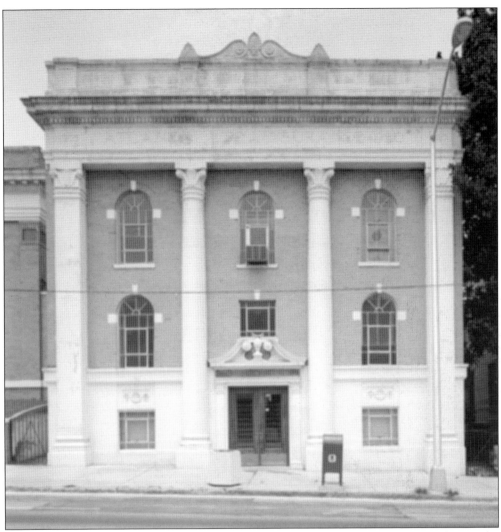

Religious, academic, and recreation institutions were vital to mobilizing blacks during the voter registration campaign of 1946. Often overlooked in this effort are financial institutions. Throughout the civil rights movement, the Atlanta Life Insurance Company, Citizen Trust Bank, and other local black-owned businesses supported the quest for social, political, and economic justice. Pictured is the Atlanta Life Insurance Company on Auburn Avenue. The company was founded in 1905 by former slave Alonzo Herndon. His son Norris served as the company's second president. Executives of the company, Eugene Martin, Charles Greene, E.L. Simon, and Jesse Hill Jr., were key figures in supporting various civil rights demonstrations, from the Montgomery bus boycott to the march from Selma to Montgomery. Norris Herndon is credited as possibly the largest financial contributor of the modern civil rights movement. (Library of Congress Prints and Photography Division.)

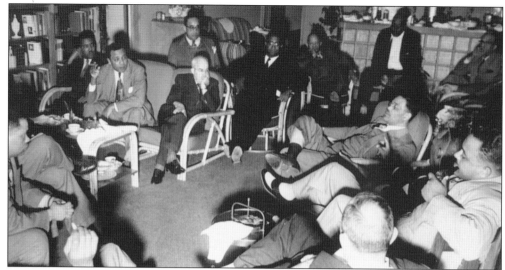

Members of Atlanta's black elite often gathered in private residences to discuss tactics to improve social, political, and economic conditions in the city and beyond. All the men pictured here became cofounders and supporting members of the All-Citizens Registration Committee under the leadership of the local NAACP. Members of this organization and others brokered an agreement with Mayor William B. Hartsfield to hire black police officers and improve black neighborhoods in return for securing 10,000 registered voters for a forthcoming mayoral election. The community leaders exceeded the mayor's expectation by registering more than 21,000 black voters in less than a two-month period in 1946. (Google Arts and Culture.)

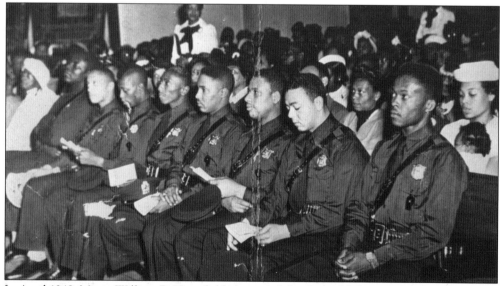

In April 1948, Mayor William B. Hartsfield integrated the City of Atlanta Police by hiring eight African American men to serve as police officers. Photographed during an NAACP-sponsored program held at Greater Mount Calvary Baptist Church on April 30, 1948, are, from left to right, Willie Elkins, William Strickland, John H. Sanders, Robert McKibbens, Ernest Lyons, Johnnie P. Jones, Henry Hooks, and Claude Dixon.

Two

AND NONE SHALL
MAKE THEM AFRAID

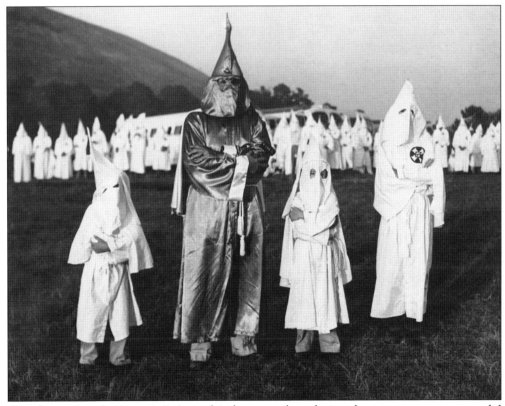

As African American voters increased in large numbers during the postwar years, so too did recruitment of white supremacy groups. Flanked by three young initiates is Dr. Samuel Green, grand dragon of the Ku Klux Klan, on July 23, 1948, while standing before Stone Mountain.

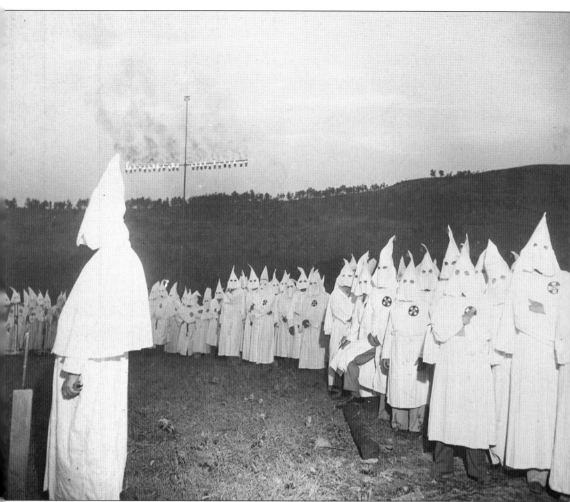

Racial violence and police brutality against blacks in Atlanta heightened following World War II. Recognizing the potential of their voting strength, an influential group of black business and civic leaders orchestrated a mass registration campaign in 1948 that led to the hiring of Atlanta's first black police officers, causing police brutality to be curtailed. Unfortunately, the same could not be said for racial hostility and intimidation, which heightened as more whites became aware of the negotiating power of blacks to win the support of affluent whites and to determine the fate of election outcomes. To fight against the largest and strongest number of black voters in the southern Black Belt, recruitment from white supremacy groups increased dramatically in the Metro Atlanta area. However, hate groups such as the Ku Klux Klan were not able to secure enough support to suppress the black vote in the city following 1948. Here, a cross burns as 700 members are initiated into the KKK at Stone Mountain on July 23, 1948.

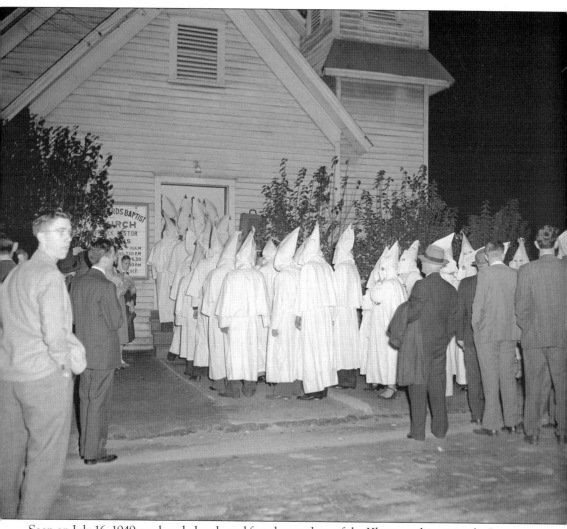

Seen on July 16, 1949, are hooded male and female members of the Klan marching into the Inman Yards Baptist Church in Atlanta to attend Sunday evening service.

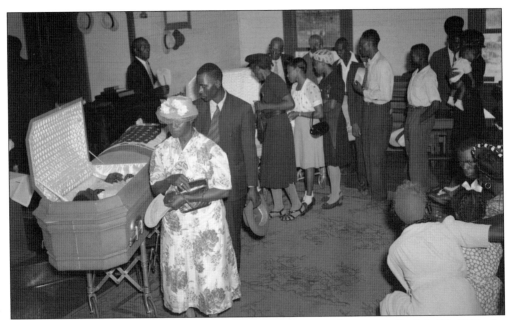

Atlanta was profoundly affected by racial tension from surrounding cities. On July 26, 1946, the city rose to the news of a mass lynching in Walton County, 45 miles beyond the Atlanta city limit. The *Atlanta Daily World, Atlanta Constitution,* and *Atlanta Journal* identified the four victims executed on a dirt road near the Moore's Ford bridge as World War II veteran George Dorsey, Mae Murray Dorsey, Dorothy Malcom, and Roger Malcom.

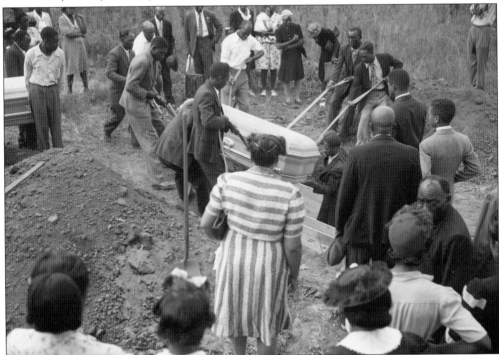

Atlanta newspapers did not shy away from bringing attention to the quadruple murder of two black couples. Here, mourners bury the victims at Mount Perry Baptist Church in Bishop, Georgia.

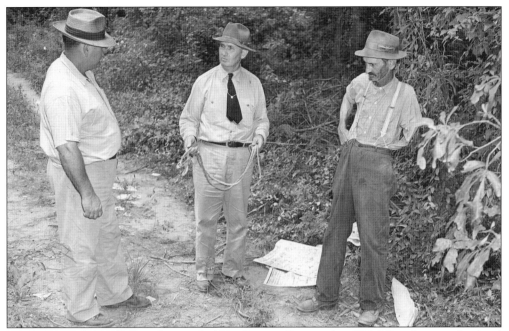

Loy Harrison (left) tells how the rope held by Oconee County sheriff J.M. Bond was used to bind the victims. Harrison, the only person to provide scant testimony, stated that he witnessed his four black employees die brutally as 60 bullets were fired by an angry mob of masked men. The case was never solved.

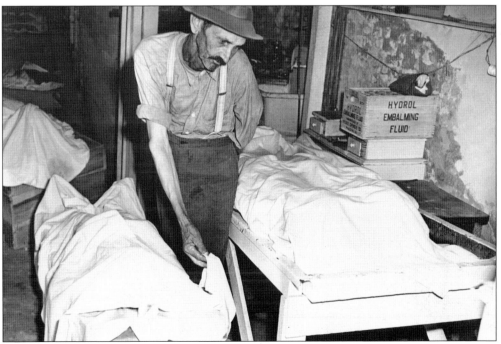

The *Atlanta Daily World* covered the story of the mass lynching longer than any other news source in the United States. Here, coroner W.T. Brown places sheets over the bodies of the four victims of "the Last Mass Lynching in America."

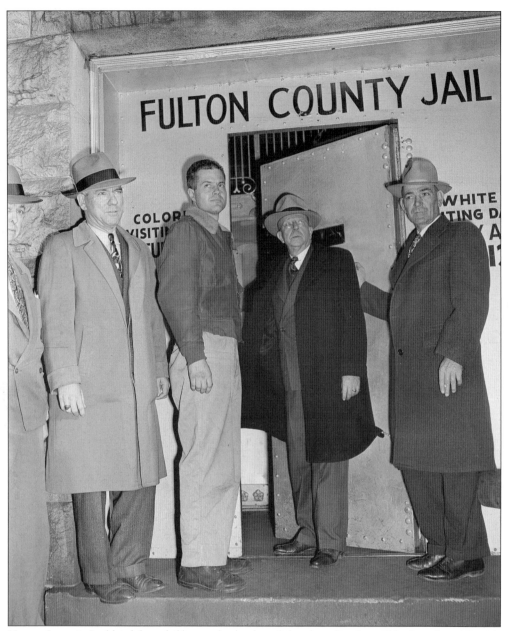

Homer Loomis Jr. (third from left) was the leader of the short-lived anti-black and anti-Jewish organization the Columbians Inc. Loomis is pictured entering the Fulton County Jail. He was found guilty, along with co-founder Emory Burke, of inciting a riot and usurpation of the police force in 1947. Member Ira Jett was also convicted of possession of dynamite and conspiring to use explosives against black families residing on Ashby Street, now Joseph E. Lowery Boulevard. The Columbians members were sentenced to a year of hard labor in prison and jail time for each charge.

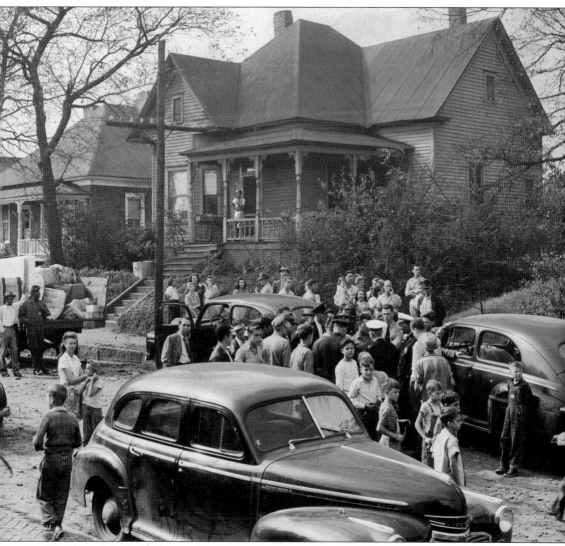

Four leaders of the Columbians, the nation's first neo-Nazi organization, were arrested on November 2, 1946, for inciting a riot as a black couple, Mr. and Mrs. Frank Jones, attempted to move into a rental property on 727 Garibaldi Street Northwest, formerly occupied by white tenants. Among the more than 50 individuals involved in the demonstration, Homer L. Loomis Jr., James M. Akins, Jack Price, and R.L. Whitman were arrested by Capt. W.M. Weaver. Unbeknownst to the hate group, the Columbians were under investigation by white law enforcement for physically assaulting and promoting violence against African Americans and Jews in the city.

A core group of white Atlantans belonging to the Non-Sectarian Anti-Nazi League (NAZL) worked to dismantle the Columbians hate group. Two former Columbians members, Ralph Childers (far right) and Lanier Waller (second from right) and undercover agent of the NAZL Renee Fruchtbaum (second from left) are pictured with Georgia assistant district attorney Dan Duke (center), who referred to the Columbians as "juvenile delinquents of the Klan."

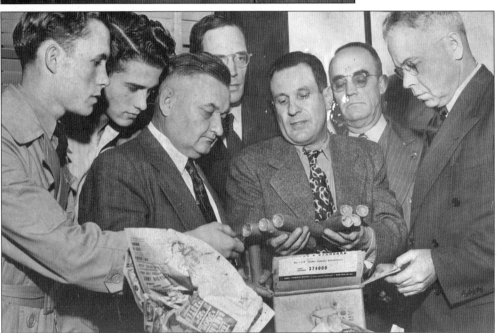

Testimony from former Columbians Lanier Waller (far left) and Ralph Childers (second from left) led to the conviction of its leaders in 1947. Anti-Nazi investigator Mario Buzzi (center) displays dynamite allegedly confiscated from the Columbians' store of explosives. Also involved in exposing the Columbians, from center to right, were Solicitor General "Shorty" Andrews, Prof. James H. Sheldon of the Anti-Nazi League, detective I.M. Eason, and police chief M.A. Hornsby.

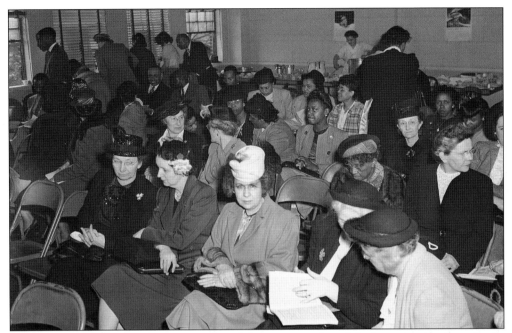

Despite Jim Crow laws and customs, some Atlantans were hopeful of creating a more tolerant society. The Southern Regional Council (SRC) and 11 additional organizations sponsored an event to discuss the city's social challenges. The event, held at the Lutheran Church of the Redeemers, was organized in response to African Americans and Jews experiencing hostility and intimidation from the Atlanta police, the Columbians, and the Ku Klux Klan.

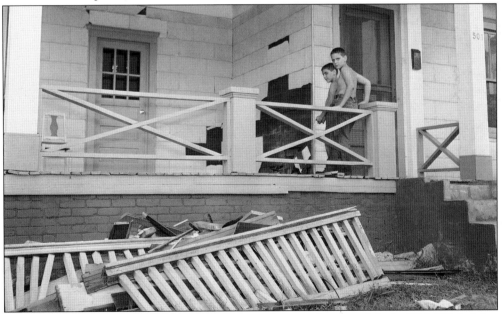

Carl Haynes and his wife moved into a majority-white residence on July 2, 1956. While lying in bed, the couple's rental home was bombed, blasting a large opening in front of the home and ripping the rails entirely from the front porch. Needless to say, the black couple moved the following day.

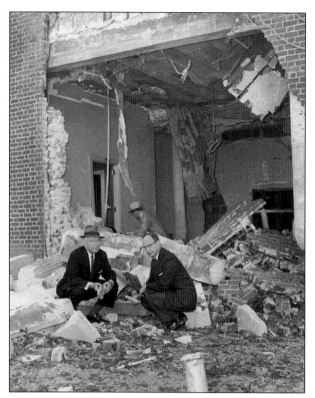

Racial intimidation was not confined to blacks alone. On the morning of October 12, 1958, a Jewish synagogue, The Temple, was bombed. Here, Mayor William B. Hartsfield (left) and Rabbi Jacob Rothchild examine the rubble. The bombing was a response to the rabbi advocating for racial equality and the end of segregation in the city. Members of the white supremacy group the Confederate Underground used more than 50 sticks of dynamite to take down the north entrance of The Temple. The explosion, causing more that $100,000 in damage, occurred on the morning of service. Fortunately, there were no injuries or deaths. Members of the synagogue continued regular service the following week despite this cowardly attempt to intimidate.

During the first Shabbat service following The Temple's bombing, Rabbi Jacob Rothchild gave one of his most memorable sermons, "And None Shall Make Them Afraid." Fearlessly, he spoke the following words to members of the synagogue: "This despicable act has made brighter the flame of courage and renewed in splendor the fires of determination and dedication. It has reached the hearts of men everywhere and roused the conscience of a people united in righteousness. All of us together shall rear from the rubble of devastation, a city and a land in which all men are truly brothers and none shall make them afraid."

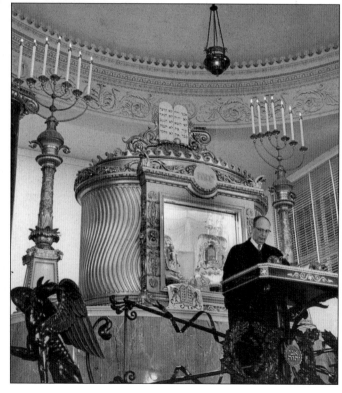

Three

DESTROYING JIM CROW AND ENFORCING THE BROWN DECISION

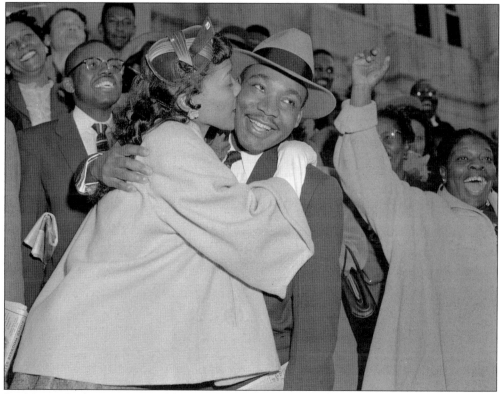

Dr. Martin Luther King Jr. and his wife returned to Atlanta following the successful 381-day Montgomery bus boycott. Within days of the couple's arrival in January 1957, Atlanta religious and civil rights leaders challenged the segregation laws of Atlanta's public transportation system by testing the US Supreme Court decision desegregating buses in Montgomery, Alabama.

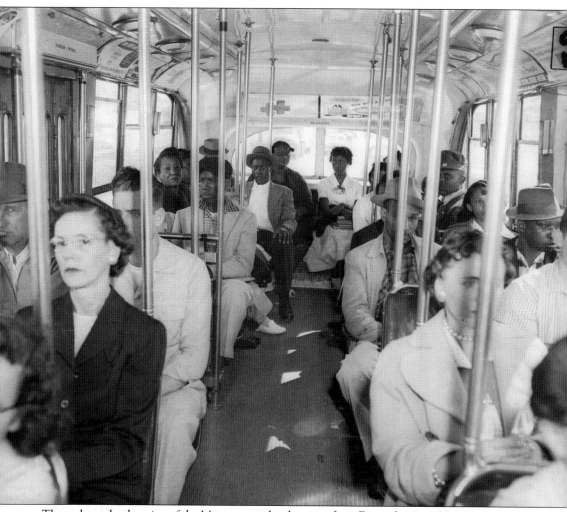

Throughout the duration of the Montgomery bus boycott, from December 1, 1955, to December 20, 1956, the Atlanta bus system continued racial segregation practices. In this April 1956 photograph, blacks are shown sitting in the rear of a bus while whites are assigned seating in the front. To avoid arrest for violating Georgia's segregation laws, black passengers had to subject themselves to giving up preferential seating to whites.

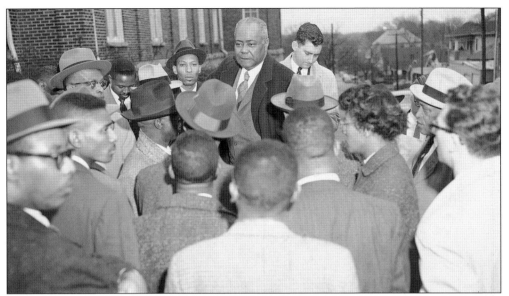

With the exception of Georgia, African Americans in cities of three southern states—Louisiana, Florida, and Alabama—organized mass boycotts against segregated bus systems between 1953 and 1956. In January 1957, African American religious leaders in Atlanta hoped to desegregate the city's transportation system by intentionally sitting in seats reserved for whites. Awaiting a public bus, Rev. Williams Holmes Borders, pastor of Wheat Street Baptist Church, instructed participants, including a woman, on how to carry out the demonstration.

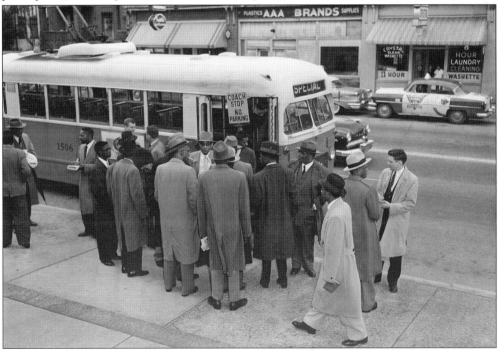

On January 9, 1957, clergymen are entering the front door of a bus, a violation for African American passengers. Six of the twenty demonstrators defied Atlanta's public transit regulations by riding for nearly 36 blocks in the "whites-only" section of the bus.

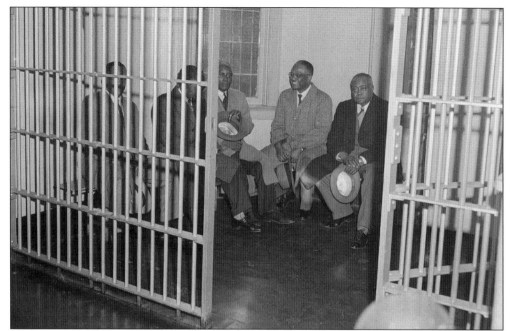

The campaign to desegregate Atlanta's public buses was called the "Triple L" (Law, Love, and Liberation) movement. Rev. William Holmes Borders (far right) and four ministers were arrested for occupying "whites-only" seats. In 1959, a federal district court decision ordered that the integration of public transformation commence on January 22.

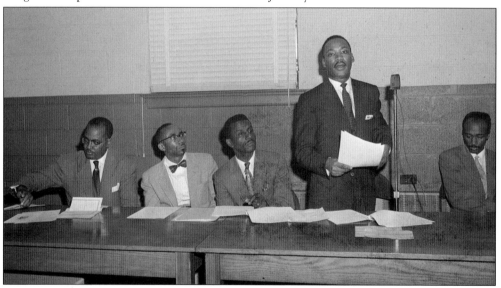

On January 10–11, 1957, sixty ministers and civil rights leaders from across the United States met at Ebenezer Baptist Church to build upon the successful non-violent strategies employed during the Montgomery bus boycott. From this meeting, the Southern Christian Leadership Conference (SCLC) was formed with Dr. Martin Luther King Jr. chosen as its first president. Presenters were civil rights leaders from four major cities. From left to right are Revs. T.J. Jemison of Baton Rouge, Louisiana; C.K. Steele of Tallahassee, Florida.; F.L. Shuttlesworth of Birmingham, Alabama.; and Dr. King.

Ebenezer Baptist Church *WORKING*
407 Auburn Avenue
Atlanta, Georgia *PAPERS*

January 10 - 11, 1957 *for*
∞∞∞∞∞∞∞∞∞ *Foun-g.*
 of
W O R K I N G P A P E R #1 *SCLC.*

THE MEANING OF THE BUS PROTEST
in the
SOUTHERN STRUGGLE FOR TOTAL INTEGRATION

In analyzing the Bus Protest certain factors emerge:

1. These protests are directly related to economic survival,
 since the masses of people use busses to reach their work.
 The people are therefore interested in what happens in
 busses.

2. The people know that in bus segregation they have a just
 grievance. No one had to arouse their social anger.

3. In refusing to ride the busses the people pledge a daily
 rededication. This daily act becomes a matter of group pride.

4. Unlike many problems, such as integrated education, there
 is no administrative machinery and legal maneuvering that
 stand between the people and the act of staying off the
 busses, or sitting in front seats. The situation permits
 direct action.

5. The campaign is based on the most stable social institution
 in Negro culture - the church.

6. The protest requires community sharing through mass meetings,
 contributions, economic assistance, hitchhiking etc.

7. The situation permits and requires a unified leadership.

8. The method of non-violence - Christian love, makes humble
 folk noble and turns fear into courage.

9. The exigencies of the struggle create a community spirit
 through community sacrifice.

N O T E :
The underlined words are 9 qualities required for mass movement.
When a group of people have developed them in one area, these qualities
can be transferred to any other constructive one through education
by action, the final quality.

Collectively, master strategists and organizers Ella Baker, Bayard Rustin, and Stanley Levison drafted a working paper offering an analysis of southern bus protests for the Southern Negro Leaders Conference held in January 1957 at Ebenezer Baptist Church. The nine factors listed would serve as a blueprint for organizing a mass movement for full integration and economic reform through nonviolent protest and "education by action." The conference was renamed as the Southern Christian Leadership Conference, also known as SCLC. (Bayard Rustin Papers, Manuscript Division, Library of Congress.)

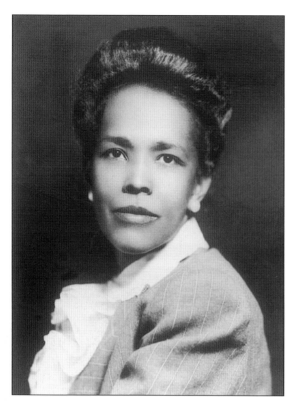

Legendary civil rights leader Ella Baker moved to Atlanta in 1957 to form the SCLC with Bayard Rustin and Dr. King. She departed from the organization in 1960 and devoted herself to the student-led organization SNCC. (Library of Congress, Prints and Photograph Division, NAACP Papers.)

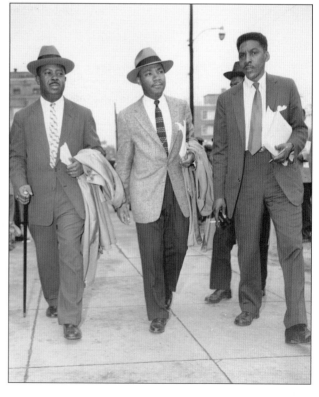

Dr. King is flanked by two of his closest supporters and organizers of the civil rights movement, Rev. Ralph David Abernathy (left) and Bayard Rustin. Rustin helped to develop SCLC in its embryonic stage and Abernathy later served as the second president of the organization following Dr. King's death.

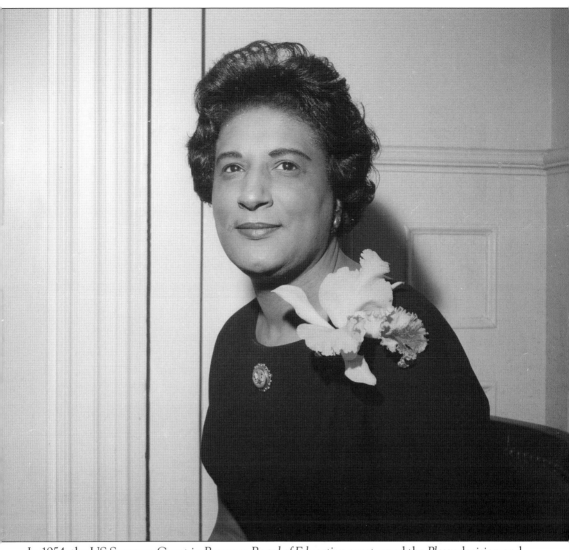

In 1954, the US Supreme Court in *Brown v. Board of Education* overturned the *Plessy* decision and declared the system of legal segregation unconstitutional and "inheritably unequal." In Georgia and beyond, the implementation of that decision occurred at "deliberate speed." Constance Baker Motley of the NAACP Legal Defense Fund and Education Fund (LDF) served as the lead attorney for cases that resulted in the integration of the Atlanta Public School District, the University of Georgia, and Georgia State University College of Business Administration. Winning 9 of 10 cases before the US Supreme Court, she went on to become the first African American woman to hold a federal judgeship.

Constance Baker Motley of the LDF, A.T. Walden (left), and Donald Lee Hollowell (right) served as attorneys for Horace T. Ward (center) in his pursuit of admittance to the University of Georgia Law School. After a seven-year battle, the case was dismissed in 1957. Ward eventually pursued a law degree from Northwestern University. He returned to Atlanta to practice law and, in 1961, worked alongside Motley, Walden, and Hollowell in ending 176 years of segregation practices at the University of Georgia.

Attorney Constance Baker Motley (right) is pictured during a reception dinner with Dr. Martin Luther King Jr. and Coretta Scott King.

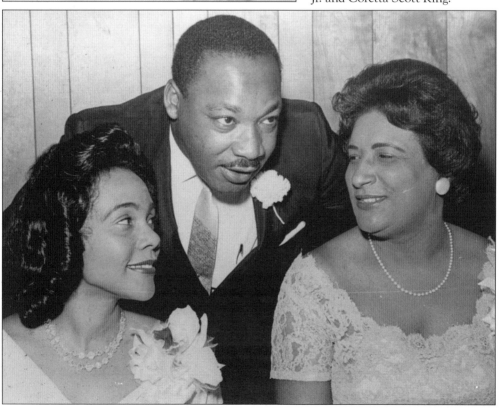

In June 1959, ten African American parents filed suit against the Atlanta Public School District aiming to outlaw racial segregation. Pictured are seven of the ten plaintiffs waiting to enter the US District Court: From left to right are (seated) Hudie McDowell, Ralph Swann, Ruth Smith, and Roosevelt Winfrey; (standing) Dock C. Putnam, Leonard C. Jackson, and Rev. W.M. Calhoun.

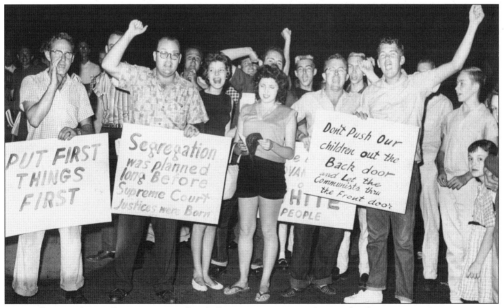

More than 125 people opposing school desegregation stood outside the governor's mansion in Atlanta on July 13, 1959, chanting, "Two, four, six, eight! We don't want to integrate!" Inside the mansion, Gov. Ernest Vandiver and 20 attorneys and legislators were busy drafting plans to sustain the legal battle against the integration of Georgia's public schools.

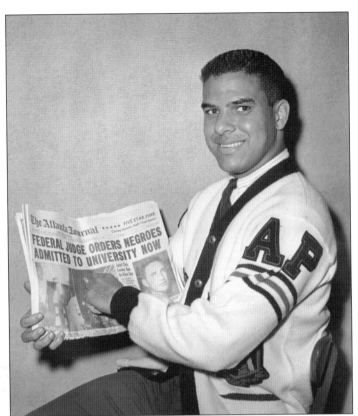

Hamilton E. Holmes and Charlayne Hunter of Atlanta were admitted to the University of Georgia in January 1961. Here, Holmes displays the headline of an *Atlanta Journal* story, "Federal Judge Orders Negroes Admitted to University Now."

Constance Motley of the LDF served as the head of the Holmes-Hunter legal team along with attorneys Donald L. Hollowell, Horace Ward, and Vernon Jordan. From left to right, attorney Hollowell is pictured with Charlayne Hunter and Hamilton E. Holmes. (The Herndon Home Museum.)

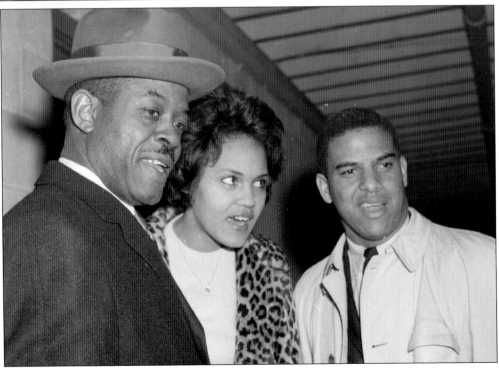

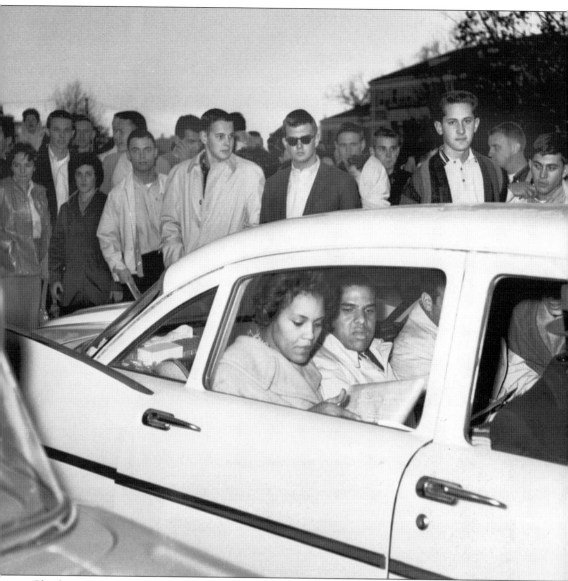

Charlayne Hunter and Hamilton E. Holmes experienced shouts and sneers from University of Georgia students after registering as full-time students. Upon their arrival, the two Atlantans were escorted throughout the former all-white campus.

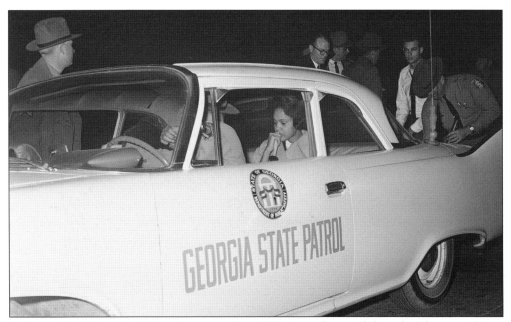

A riot on the University of Georgia campus forced the immediate withdrawal of the two African American students, Hunter and Holmes. A teary-eyed Hunter is seen clutching a Madonna statue as she is escorted off campus by the Georgia State Patrol on January 11, 1961.

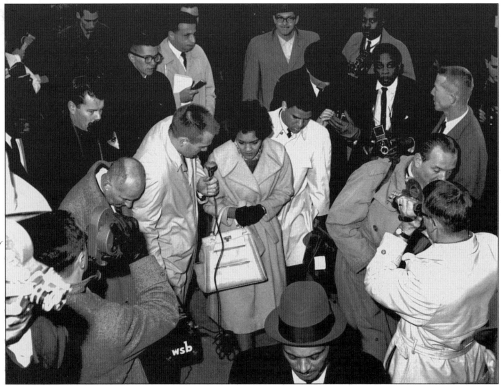

Charlayne Hunter and Hamilton E. Holmes were readmitted under court order, causing their return to the Athens, Georgia, campus on January 16, 1961.

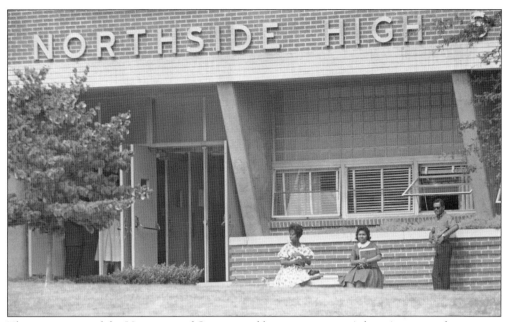

The integration of the University of Georgia and boycotts against Atlanta's premier department stores pressured lawmakers and business leaders to desegregate the city's public schools. In August 1961, a total of 9 out of 133 African-American students were granted transfers to attend all-white schools. The three schools to receive the students were Northside, Grady, and Brown High Schools.

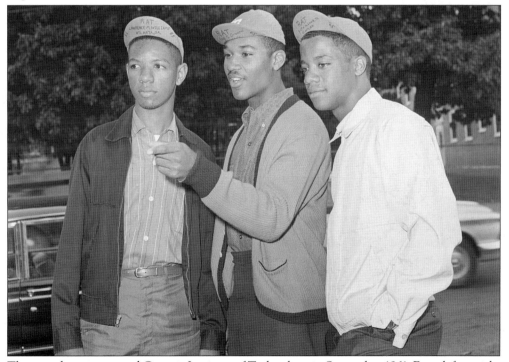

Three students integrated Georgia Institute of Technology in September 1961. From left to right are Lawrence M. Williams, Ford C. Green, and Ralph A. Long Jr.

Hamilton E. Holmes and Charlayne Hunter graduated from the University of Georgia in 1963. Holmes earned a Phi Beta Kappa key and a bachelor of science degree with honors. He went on to become an orthopedic surgeon in Atlanta. Hunter, later known as Charlayne Hunter-Gault, received a bachelor of art degree in journalism. Her career comprised of working with the *New York Times*, PBS, and NPR, where she earned numerous awards, include two Peabody Awards. A year before the graduation of Hamilton and Hunter, Atlanta native Mary Francis Early received a master's degree in music education, making her the first African American to earn a degree from the University of Georgia.

Four

ATLANTA'S STUDENT MOVEMENT AND SNCC

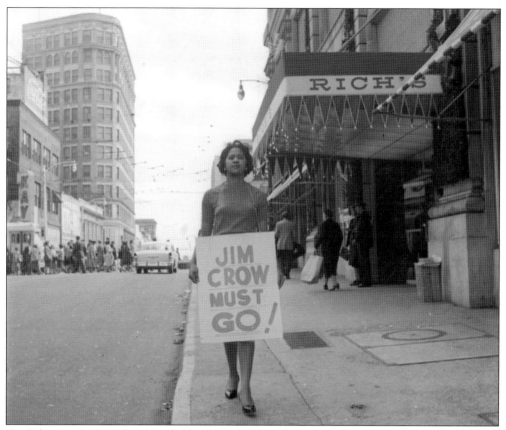

On February 1, 1960, four North Carolina A&T students staged a sit-in at a segregated lunch counter in Greensboro, North Carolina. The students' emotional fortitude and physical restraint, captured by the lenses of reporters, exposed a new generation of young adults to nonviolent direct activism. Inspired like other college students attending historically black colleges across the United States, Atlanta University Center (AUC) students mobilized to launch a series of demonstrations to end legalized segregation in public facilities. In March 1960, the Committee on the Appeal for Human Rights (COAHR) was formed. The student-led organization homed in on Atlanta's downtown commercial district as ground zero and confronted proponents of Jim Crow laws and customs. (The Herndon Home Museum.)

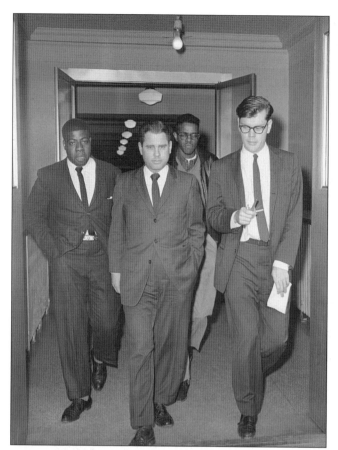

The morning following the student-led lunch counter demonstration in Greensboro, Morehouse College students William Andrews (far left) and Alton Hornsby (background) attempted to integrate the segregated seating area in the Georgia State Capitol by sitting with their white professor Dr. Ovid Futch (center). All three men were ejected by doorkeeper J. Robert Smith (far right) for violating Georgia's segregation law.

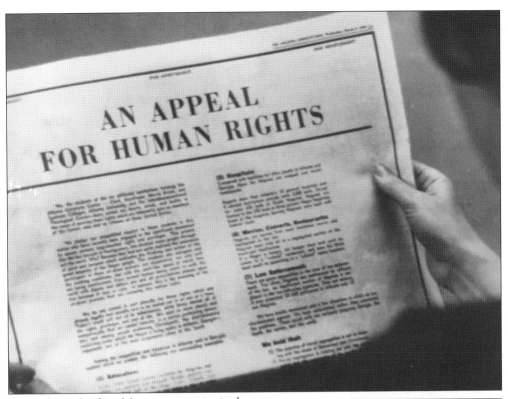

The Atlanta Student Movement was ignited by the publication of "An Appeal for Human Rights," presented as a paid full-page ad in the *Atlanta Constitution*, *Atlanta Journal*, and *Atlanta Daily World* on March 9, 1960. Student government leaders representing Atlanta University, Clark College, Morehouse College, Spelman College, Morris Brown, and the Interdenominational Theological Center demonstrated their solidarity for civil and human rights by signing their names to the manifesto.

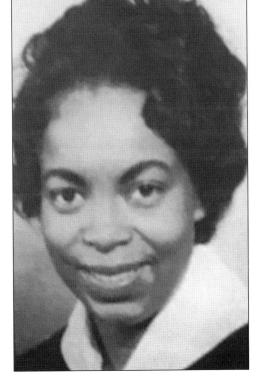

"An Appeal for Human Rights" was written by Roslyn Pope, SGA president of Spelman College. Signed by AUC student leaders, the demands in the 1960 manifesto articulated the tenets of the modern civil rights movement.

AN APPEAL FOR HUMAN RIGHTS

We, the students of the six affiliated institutions forming the Atlanta University Center — Clark, Morehouse, Morris Brown, and Spelman Colleges, Atlanta University, and the Interdenominational Theological Center—have joined our hearts, minds, and bodies in the cause of gaining those rights which are inherently ours as members of the human race and as citizens of these United States.

We pledge our unqualified support to those students in this nation who have recently been engaged in the significant movement to secure certain long-awaited rights and privileges. This protest, like the bus boycott in Montgomery, has shocked many people throughout the world. Why? Because they had not quite realized the unanimity of spirit and purpose which motivates the thinking and action of the great majority of the Negro people. The students who instigate and participate in these sit-down protests are dissatisfied, not only with the existing conditions, but with the snail-like speed at which they are being ameliorated. Every normal human being wants to walk the earth with dignity and abhors any and all prescriptions placed upon him because of race or color. In essence, this is the meaning of the sit-down protests that are sweeping this nation today.

We do not intend to wait placidly for those rights which are already legally and morally ours to be meted out to us one at a time. Today's youth will not sit by submissively, while being denied all of the rights, privileges, and joys of life. We want to state clearly and unequivocally that we cannot tolerate, in a nation professing democracy and among people professing Christianity, the discriminatory conditions under which the Negro is living today in Atlanta, Georgia—supposedly one of the most progressive cities in the South.

Among the inequalities and injustices in Atlanta and in Georgia against which we protest, the following are outstanding examples:

(1) Education:

In the Public School System, facilities for Negroes and whites are separate and unequal. Double sessions continue in about half of the Negro Public Schools, and many Negro children travel ten miles a day in order to reach a school that will admit them. On the university level, the state will pay a Negro to attend a school out of state rather than admit him to the University of Georgia, Georgia Tech, the Georgia Medical School, and other tax-supported public institutions.

According to a recent publication, in the fiscal year 1958 a total of $31,632,057.18 was spent in the State institutions of higher education for white only. In the Negro State Colleges only $2,001,177.06 was spent. The publicly supported institutions of higher education are inter-racial now, except that they deny admission to Negro Americans.

(2) Jobs:

Negroes are denied employment in the majority of city, state, and federal governmental jobs, except in the most menial capacities.

(3) Housing:

While Negroes constitute 32% of the population of Atlanta, they are forced to live within 16% of the area of the city.

Statistics also show that the bulk of the Negro population is still:

a. locked into the more undesirable and overcrowded areas of the city;

b. paying a proportionally higher percentage of income for rental and purchase of generally lower quality property;

c. blocked by political and direct or indirect racial restrictions in its efforts to secure better housing.

(4) Voting:

Contrary to statements made in Congress recently by several Southern Senators, we know that in many counties in Georgia and other southern states, Negro college graduates are declared unqualified to vote and are not permitted to register.

(5) Hospitals:

Compared with facilities for other people in Atlanta and Georgia, those for Negroes are unequal and totally inadequate.

Reports show that Atlanta's 14 general hospitals and 9 related institutions provide some 4,000 beds. Except for some 430 beds at Grady Hospital, Negroes are limited to the 250 beds in three private Negro hospitals. Some of the hospitals barring Negroes were built with federal funds.

(6) Movies, Concerts, Restaurants:

Negroes are barred from most downtown movies and segregated in the rest. Negroes must even sit in a segregated section of the Municipal Auditorium. If a Negro is hungry, his hunger must wait until he comes to a "colored" restaurant, and even his thirst must await its quenching at a "colored" water fountain.

(7) Law Enforcement:

There are grave inequalities in the area of law enforcement. Too often, Negroes are maltreated by officers of the law. An insufficient number of Negroes is employed in the law-enforcing agencies. They are seldom, if ever promoted. Of 830 policemen in Atlanta only 35 are Negroes.

We have briefly mentioned only a few situations in which we are discriminated against. We have understated rather than overstated the problems. These social evils are seriously plaguing Georgia, the South, the nation, and the world.

We hold that:

(1) The practice of racial segregation is not in keeping with the ideals of Democracy and Christianity.

(2) Racial segregation is robbing not only the segregated but the segregator of his human dignity. Furthermore, the propagation of racial prejudice is unfair to the generations yet unborn.

(3) In times of war, the Negro has fought and died for his country; yet he still has not been accorded first-class citizenship.

(4) In spite of the fact that the Negro pays his share of taxes, he does not enjoy participation in city, county and state government at the level where laws are enacted.

(5) The social, economic, and political progress of Georgia is retarded by segregation and prejudice.

(6) America is fast losing the respect of other nations by the poor example which she sets in the area of race relations.

It is unfortunate that the Negro is being forced to fight, in any way, for what is due him and is freely accorded other Americans. It is unfortunate that some people today cannot hold to the erroneous idea of racial superiority, despite the fact that the world is fast moving toward an integrated humanity.

The time has come for the people of Atlanta and Georgia to take a good look at what is really happening in this country, and to stop believing those who tell us that everything is fine and equal, and that the Negro is happy and satisfied.

It is to be regretted that there are those who still refuse to recognize the over-riding supremacy of the Federal Law.

Our churches which are ordained by God and claim to be the houses of all people, foster segregation of the races to the point of making Sunday the most segregated day of the week.

We, the students of the Atlanta University Center, are driven by past and present events to assert our feelings to the citizens of Atlanta and to the world.

We, therefore, call upon all people in authority—State, County, and City officials; all leaders in civic life—ministers, teachers, and business men; and all people of good will to assert themselves and abolish these injustices. We must say in all candor that we plan to use every legal and non-violent means at our disposal to secure full citizenship rights as members of this great Democracy of ours.

Willie Mays
President of Dormitory Council For the Students of Atlanta University

James Felder
President of Student Government Association For the Students of Clark College

Marion D. Bennett
President of Student Association For the Students of Interdenominational Theological Center

Don Clarke
President of Student Body For the Students of Morehouse College

Mary Ann Smith
Secretary of Student Government Association For the Students of Morris Brown College

Roslyn Pope
President of Student Government Association For the Students of Spelman College

"An Appeal for Human Rights," was published in the *Atlanta Constitution, Atlanta Journal,* and *Atlanta Daily World* on March 9, 1960.

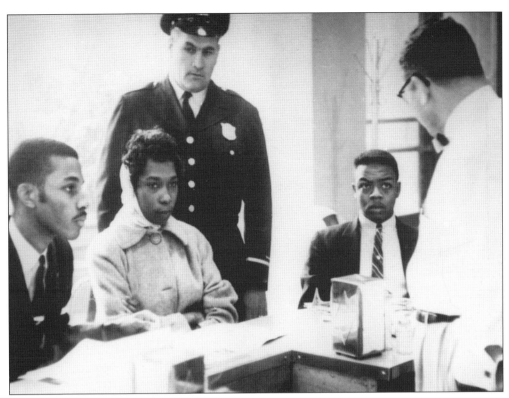

On March 15, 1960, more than 200 Atlanta University Center students participated in sit-ins at nearly a dozen lunch counters in downtown Atlanta. Unmoved by the presence of a white police officer, Victor Cobb (far right) and two unidentified college students were asked to leave the lunch counter at the Trailways Bus Terminal. The demonstrators refused to acquiesce and stared at the dining manager in silence. They were arrested amongst nearly 80 protestors.

AUC student leaders formed the Committee on Appeal for Human Rights (COAHR) on March 16, 1960. They joined forces with the old-guard of the civil rights movement and formed the Student-Adult Liaison Committee during the winter of the same year. The cross-generation of activists encouraged African Americans to boycott downtown Atlanta businesses for its discriminatory practices.

Your Turn To Act
FOR FREEDOM

-:- FIRST CLASS CITIZENSHIP AND JOB OPPORTUNITIES -:-

THE MERCHANTS HAVE FLATLY REFUSED TO LET ATLANTA NEGROES SHOP AND EAT IN DIGNITY!

———o———

IN SPITE OF A 30 DAY TRUCE PERIOD, THEY HAVE FLATLY REFUSED TO JOIN 112 OTHER SOUTHERN CITIES WHICH HAVE OPENED COUNTERS AND REST ROOMS TO ALL THEIR CUSTOMERS.

———o———

-:- Therefore, We Ask You To -:-

STAY OUT of the DOWNTOWN STORES

— On These Streets —

FORSYTH	MITCHELL
BROAD	HUNTER
WHITEHALL	ALABAMA
PEACHTREE	MARIETTA
(To Ponce de Leon)	

STAY OUT of these SHOPPING CENTERS

LENNOX SQUARE BELVEDERE PLAZA

Give FREEDOM CARDS Instead of Gifts This Christmas

———o———

THE COMMITTEE ON THE APPEAL FOR HUMAN RIGHTS
— and —
THE STUDENT-ADULT LIAISON COMMITTEE

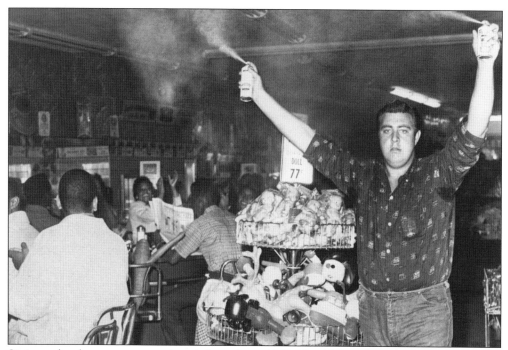

Sit-ins at local restaurants continued throughout 1960. Harold Sprayberry is captured spraying insect repellent above the heads of nearly 100 students who participated in a three-hour sit-in. The protesters applauded with amusement. Sprayberry was charged with inciting a riot.

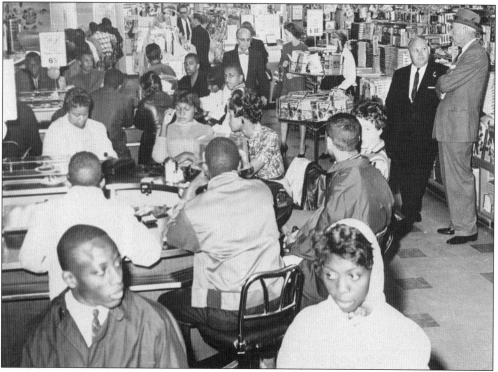

AUC students crowd the lunch counters and tables at a Woolworth in downtown Atlanta.

Clarence Seniors, a 22-year-old Morris Brown College student, attempts to end the more than 300-year-old practice of racially segregated seating arrangements in America's courtrooms by filing suit against Luke Arnold, chief of the Atlanta Municipal Court, and Atlanta mayor William B. Hartsfield on April 25, 1960.

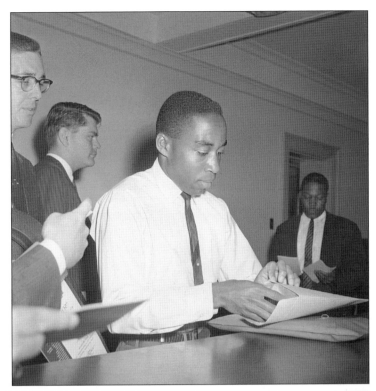

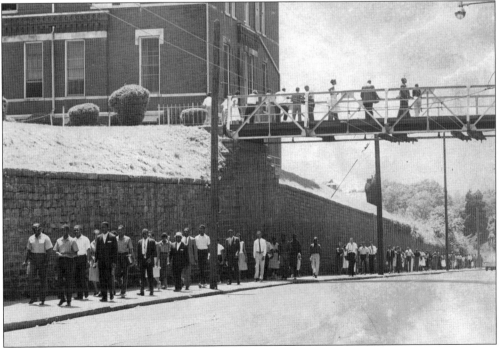

On the sixth anniversary of the *Brown* decision, COAHR organized a march from the Atlanta University Center to the Georgia State Capitol. More than 2,000 students participated in the demonstration.

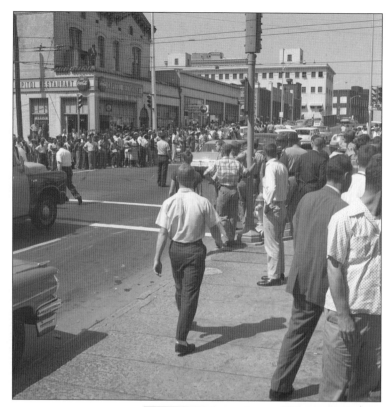

Hundreds of black and white spectators, along with dozens of state troopers, surrounded the Georgia State Capitol in anticipation of the arrival of the more than 2,000 student marchers on May 17, 1960.

Vowing to use force if necessary, a state trooper passes out billy clubs to other troopers to keep AUC student marchers from occupying the grounds of the Georgia State Capitol. Learning that troopers had surrounded the capitol and concerned for their safety, the students concluded their march in commemoration of the *Brown* decision at Wheat Street Baptist Church on Auburn Avenue.

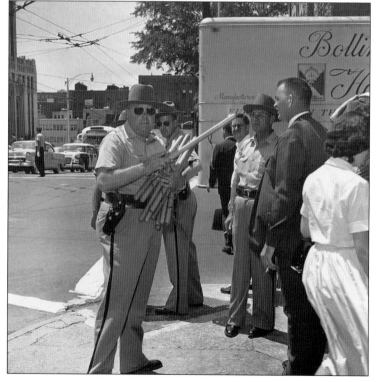

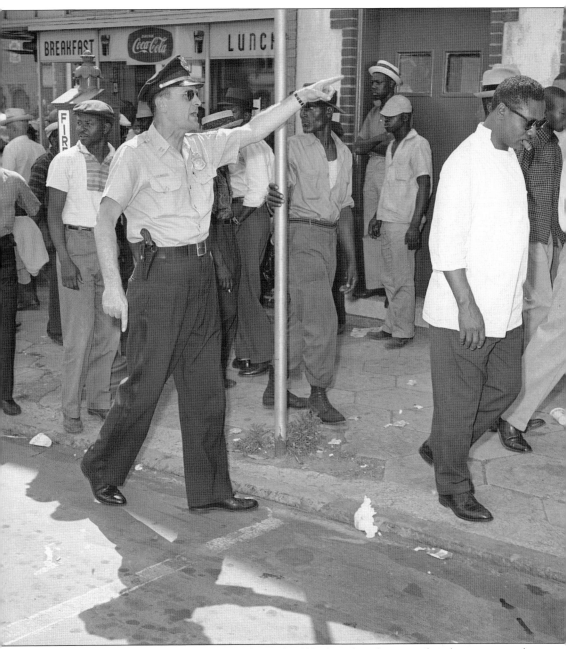

White police officers proceeded to disband crowds of black males who arrived to the state capitol to support the AUC student marchers and offer protection from law enforcement if the situation required it.

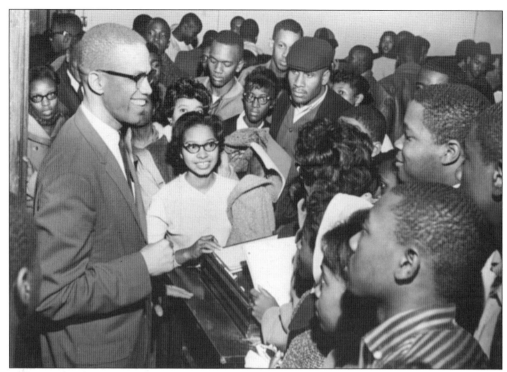

Malcolm X, impressed by the activism of the Atlanta student-led movement, paid a visit to Clark College in 1960.

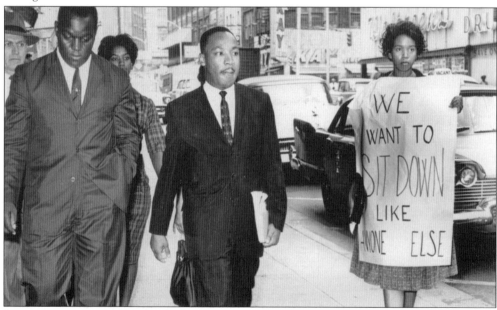

Participating in a "Jail-No-Bail" demonstration, Dr. Martin Luther King Jr. and four college students, Lonnie King (left, no relation), Marilyn Price (background), and Blondeen Orbent (behind Dr. King), are escorted to a police car. The four were arrested for attempting to integrate a Rich's department store restaurant on October 19, 1960. Participating alongside other picketers is Ida Rose McCree.

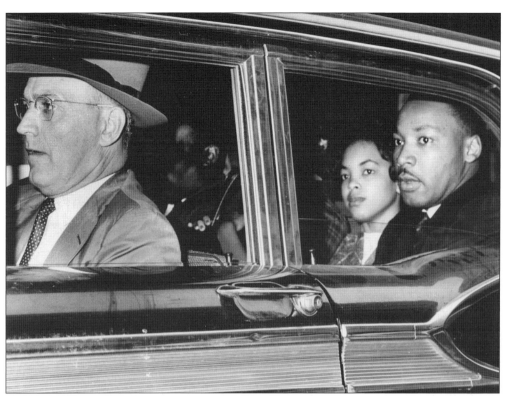

Dr. Martin Luther King Jr. was arrested along with 52 students on October 19, 1960, for violating Georgia's segregation laws. Being taken away in a police car driven by Atlanta police captain R.E. Little are Dr. King (far right) Blondeen Orbent (second from right), Marilyn Price, and Lonnie King.

As a result of the arrest at Rich's, Dr. King was sentenced to four months of hard labor at Reidsville State Penitentiary for violating probation for an earlier traffic offense. After being shackled and bound to a prison floor for eight days, he was released after his attorney Donald L. Hollowell, Attorney General Robert Kennedy, and presidential candidate Sen. John F. Kennedy intervened.

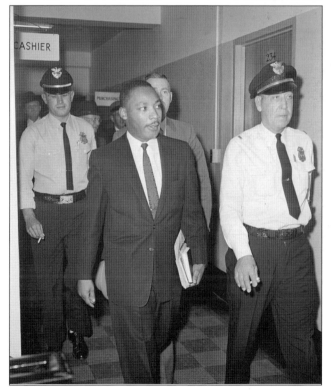

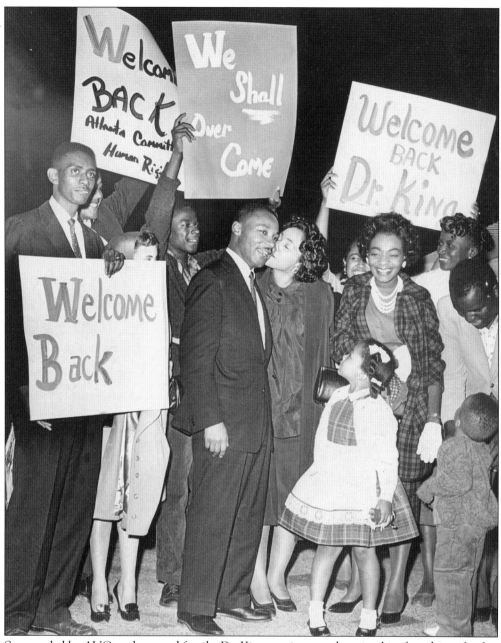

Surrounded by AUC students and family, Dr. King receives a welcoming kiss from his wife after being released from Reidsville State Prison on October 27, 1960.

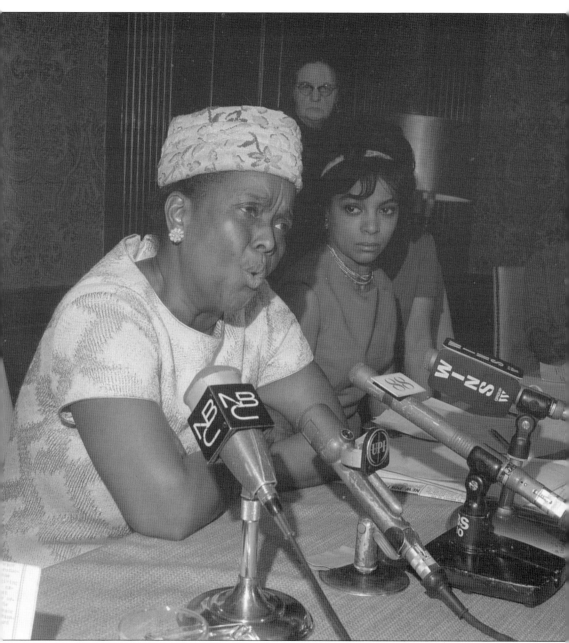

Like the COAHR of the Atlanta University Center, the Student Nonviolent Coordinating Committee (SNCC) was formed in direct response to the student-led sit-ins occurring across the United States throughout the winter and spring months of 1960. Ella Baker, secretary of the SCLC, recognized the potential of student activism "to rid America of the scourge of racial segregation and discrimination." On April 15, 1960, SCLC sponsored a three-day "Youth Leadership Meeting" at Shaw University in Raleigh, North Carolina, which attracted more than 200 southeastern sit-in leaders. There, Baker informed the conferees that the movement is "bigger than a hamburger." From this meeting, SNCC was formed, with its headquarters soon established in Atlanta. Here, Baker speaks during a press conference with actress Ruby Dee.

YOUTH LEADERSHIP MEETING
SHAW UNIVERSITY
RALEIGH, N. C. – APRIL 15-17, 1960

W H Y THIS MEETING?

Recent lunchcounter Sit-ins and other nonviolent protests by students of the South are tremendously significant developments in the drive for Freedom and Human Dignity in America.

The courageous, dedicated and thoughtful leadership manifested by hundreds of Negro students on college campuses, in large cities and small towns, and the overwhelming support by thousands of others, present new challenges for the future. This great potential for social change now calls for evaluation in terms of where do we go from here. The Easter week-end conference is convened to help find the answers. Together, we ' \ chart new goals and achieve a mc unified sense of direction for training and a..ion in Nonviolent Resistance.

W H O WILL ATTEND?

Representation is invited from all areas of recent protest. However, to be effective, a leadership conference should not be too large. For this reason, each community is being asked to send a specified number of youth leaders. Adult Freedom Fighters will be present for counsel and guidance, but the meeting will be youth centered.

S C H E D U L E :

The opening session will be Friday, April 15 at 7:30 o'clock. Saturday will be devoted to workshops, buzz-sessions and committee work. There will be a public meeting Saturday night, and the conference will close at lunchtime Sunday.

E X P E N S E S :

We believe that your community will want to help share your travel expenses; and the Southern Christian Leadership Conference hopes that housing and meals will be underwritten. The total cost for six (6) meals and housing for two (2) nights will be $6.30 per person.

FOR FURTHER INFORMATION, Contact the Southern Christian Leadership Conference, 208 Auburn Avenue, N. E., Atlanta, Ga..

Dr. Martin L. King, Jr. Ella J. Baker
President Executive Director

In this original flyer, Dr. Martin Luther King Jr. and Ella Baker of the SCLC see youth leadership as the missing link to propel the movement for social change. From this Youth Leadership Meeting at Shaw University on April 15–17, 1960, SNCC was formed. (New York Public Library.)

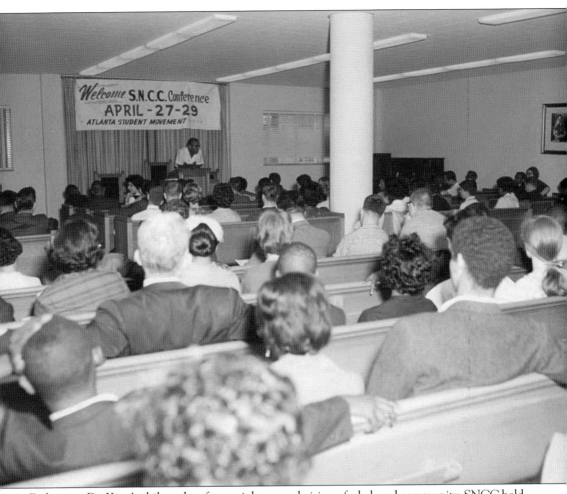

Embracing Dr. King's philosophy of non-violence and vision of a beloved community, SNCC held its first conference in Atlanta on April 27–29, 1960. In attendance were white and black student activists from across the United States. For the next six years, the autonomous organization focused on desegregation and voter registration campaigns throughout the Southern Black Belt. SNCC's most notable campaigns were the Albany Movement, Freedom Rides, Freedom Ballot, Mississippi Summer Project, March on Washington, and march from Selma to Montgomery. Its more recognizable leadership included Marion Barry, Julian Bond, James Foreman, John Lewis, Bob Moses, Ruby Doris Smith Robinson, and Jane Stembridge. From 1966, SNCC—under the chairmanship of Stokely Carmichael, and later, H. Rap Brown—espoused the philosophy of Black Power. By 1968, the organization dissolved due to a reduction in membership and active participation. (Georgia State University Archives, Tracy O'Neal Photographs.)

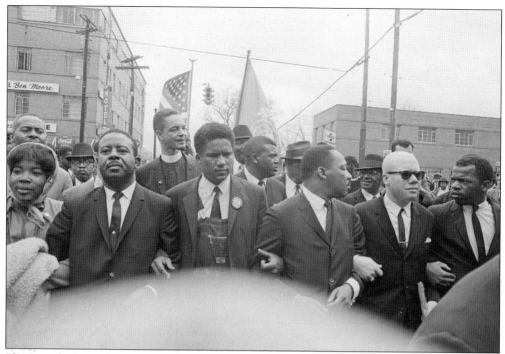

Photographed marching on the front line of the march from Selma to Montgomery are, from left to right, Rev. Ralph David Abernathy (SCLC), James Forman (SNCC), Dr. Martin Luther King Jr. (SCLC), Jesse Douglass (SNCC and graduate of the Interdenominational Theological Center, class of 1962), and John Lewis (SNCC).

Stokely Carmichael (left) stands next to Julian Bond, who served as the editor of SNCC's newsletter, *The Student Voice*.

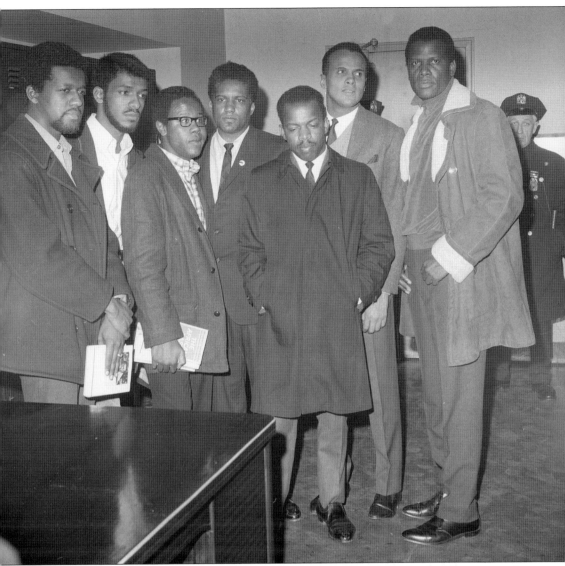

Opposing apartheid, SNCC members staged a sit-in at the office of the South African consul general in New York on March 21, 1966, the anniversary of the march from Selma to Montgomery. Actor-activists Harry Belafonte and Sidney Poitier volunteered to post bail for the five SNCC members. From left to right are William Hall, Cleveland Sellers, Willie Ricks (who coined the slogan "Black Power"), James Forman (executive secretary), and John Lewis (chairperson).

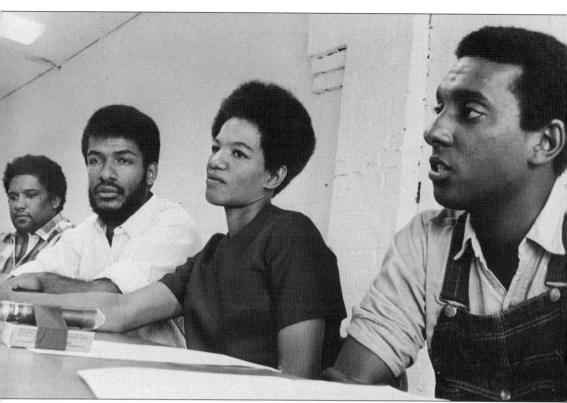

The philosophy and direction of SNCC shifted dramatically in 1966 when Stokely Carmichael (far right) succeeded John Lewis as chairperson. Ruby Doris Smith Robinson replaced James Forman as executive secretary, and Cleveland Sellers was elected as program director. Part of the dissension in the organization came because of the new Atlanta Project, a SNCC-affiliated organization that embraced tenets of black nationalism. Although influenced by the radicalism of the Atlanta Project, Carmichael fired the workers, expelled white members of SNCC, and called for Black Power, which he clarified as "a call for black people in this country to unite, to recognize their heritage, [and] to build a sense of community. It is a call for black people to define their own goals, [and] to lead their own organizations."

Five

DIRECT ACTION TACTICS

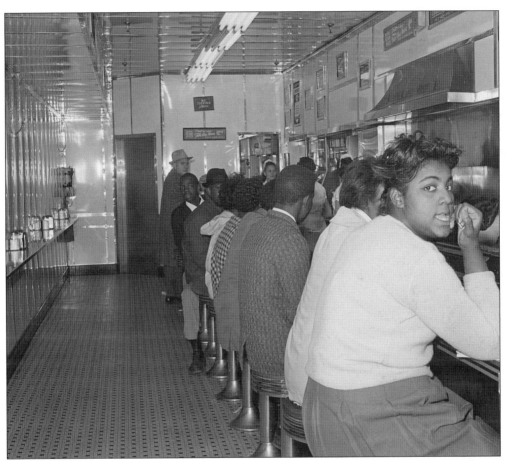

In examining African Americans' quest for personal, political, and economic autonomy during the modern civil rights movement, nonviolent direct action tactics varied based on, in the words of Congressman John Lewis, "different forms of oppression." For demonstrators, the goal of direct action was to obstruct individuals, businesses, or institutions from carrying out segregation and discriminatory practices through the use of nonviolent civil disobedience. From sit-ins to economic boycotts, this chapter offers visual examples of various tactics executed by a cross-generation of activists belonging to a variety of civil rights organizations in Atlanta. Pictured here, college students stage a sit-in at a downtown lunch counter in January 1964. By employing civil disobedience, activists deliberately violated Georgia's segregation laws to push for social change in America.

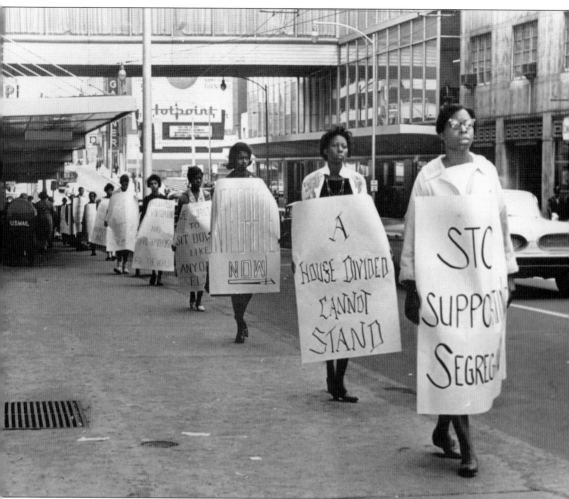

From 1960 to 1964, black Atlantans participated in boycotts against businesses in the downtown commercial district. Two primary targets were Rich's and Davison's (now Macy's) department stores. Because of the stores' discriminatory practices of disallowing African American customers to dine in their restaurants or to try on clothes or shoes, the entire black community demonstrated their solidarity by canceling their credit cards and ceased shopping with both stores altogether. Applying extra pressure, AUC students, Atlanta Life Insurance Company employees, leaders of the Student Adult Alliance, and SCLC and NAACP members picketed against the two businesses until the signing of the Civil Rights Act of 1964 by Pres. Lyndon B. Johnson. While carrying hand-painted signs, picketers orbited Rich's during a protest that led to the arrest of Dr. King and 77 students on October 19, 1960.

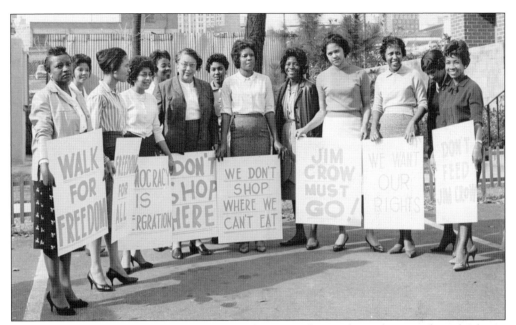

Atlanta Life Insurance Company female employees made up a large demographic of African Americans who boycotted and picketed against Rich's and Davison's department stores. (The Herndon Home Museum.)

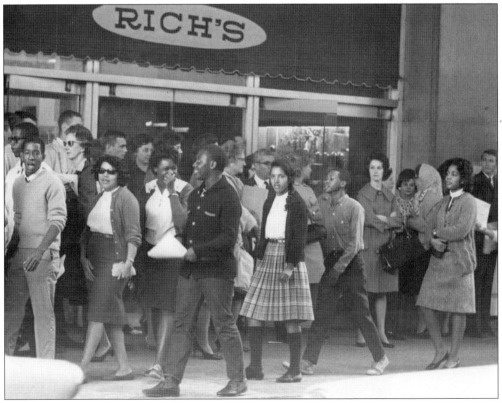

White customers look on as black youth activists protest against Rich's department store.

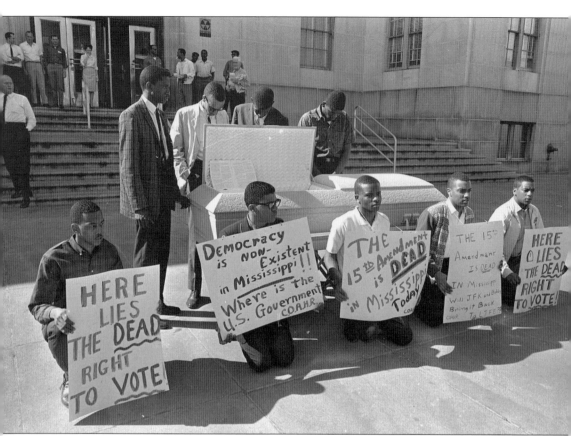

Originating in August 1960, members of the COAHR introduced "kneel-ins" while testing white churches' willingness to open their doors to African Americans. On March 30, 1963, the organization applied the tactic again while performing a mock funeral on the steps of an Atlanta post office. While carrying placards and praying before an open casket containing a copy of the 15th Amendment, the activists lamented, "The 15th Amendment is DEAD in Mississippi Today."

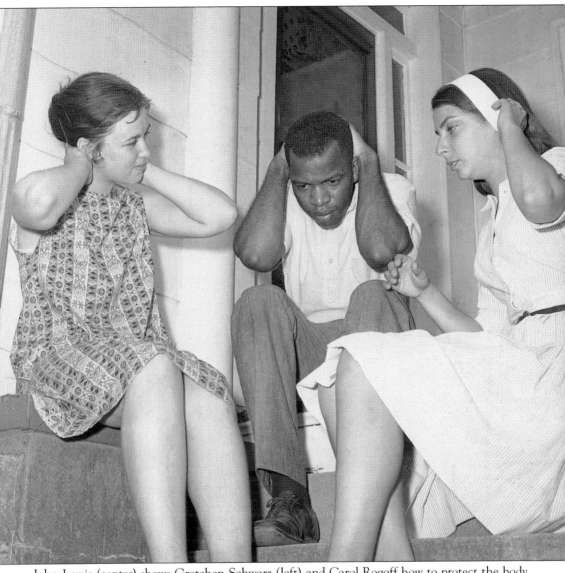

John Lewis (center) shows Gretchen Schwarz (left) and Carol Rogoff how to protect the body during a nonviolence training session in Cambridge, Massachusetts.

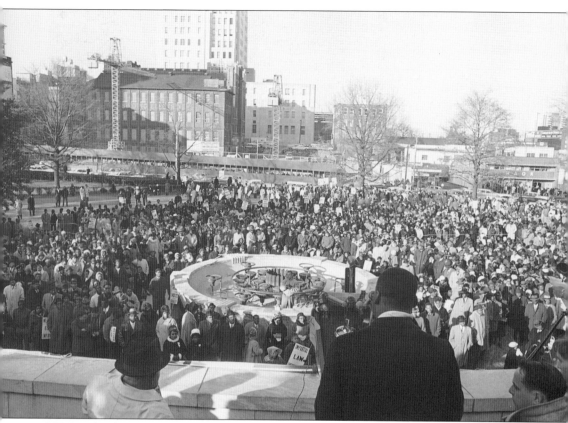

SCLC and Atlanta's black churches organized more than 2,500 African Americans to participate in a public assembly against segregation and economic inequity on December 16, 1963. Following Sunday service, the participants of the rally marched from their respective churches to assemble at Hurt Park in downtown Atlanta. The event attracted the attention of various media outlets.

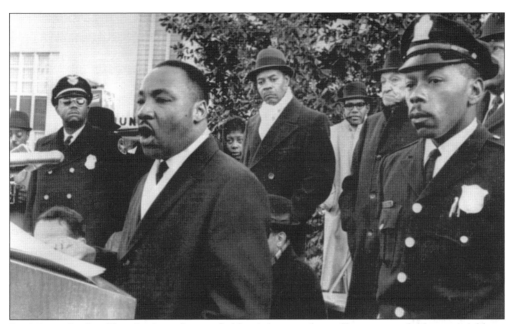

Dr. Martin Luther King Jr., heavily guarded by Atlanta police officers, gave the keynote address during a public assembly at Hurt Park on December 16, 1963.

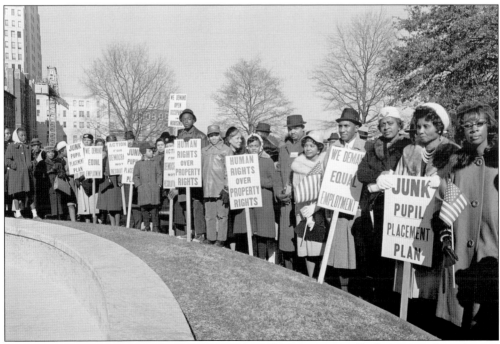

Mirroring the March on Washington for Jobs and Freedom, protesters rallied at Hurt Park to advocate for equal employment, speedier integration of public schools, and quality housing in Atlanta.

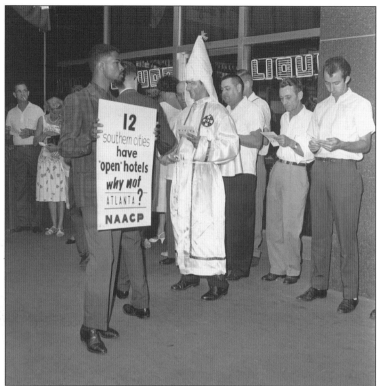

Pictured picketing before an Atlanta hotel on Independence Day 1962 is Glenn Gurley, a student at the University of Michigan. He occupies the same public space as an unmasked Klansman, who passes out handbills against the NAACP for pressuring hotels and restaurants to integrate their establishments.

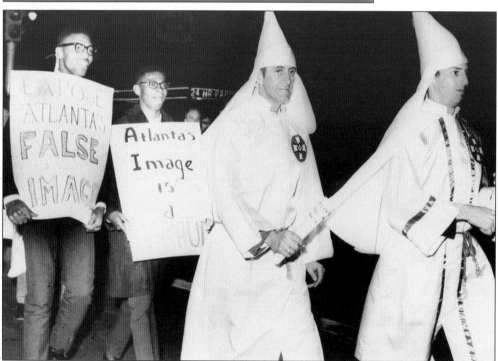

Between 1960 and 1964, the practice of civil rights activists and members of the KKK protesting simultaneously within the same public arena was not uncommon in downtown Atlanta.

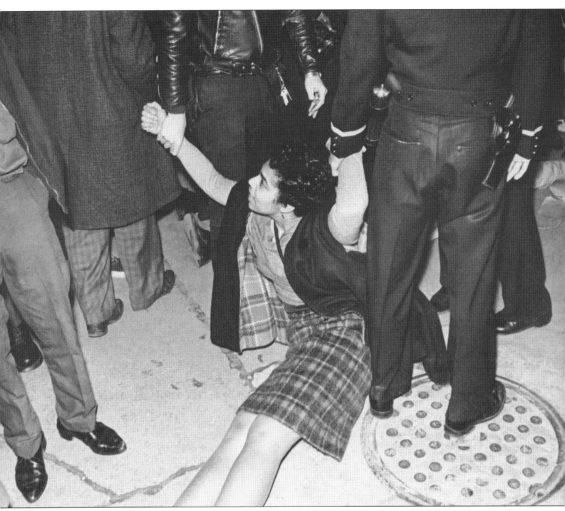

Implementing a "lay-in," protesters barricaded robed members of the Ku Klux Klan as they were drinking coffee in a downtown Atlanta restaurant. Police officers struggled for two hours to remove the demonstrators from the restaurant's entrance. Here, white officers drag a young African American woman across the cement as they attempt to place her into a paddy wagon with 24 other persons who refused arrest on January 19, 1964.

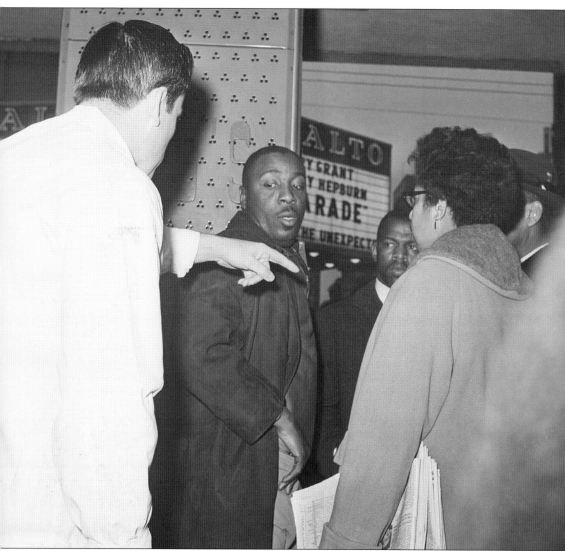

Comedian Dick Gregory (left), John Lewis (center) and other SNCC members are ordered to leave Leb's diner, a segregated restaurant located across from the Rialto theater. Gregory gives a look of caution to the owner as the protesters exit the restaurant. To prevent others from entering the restaurant, the protesters laid down in the street's intersection, which resulted in their arrest.

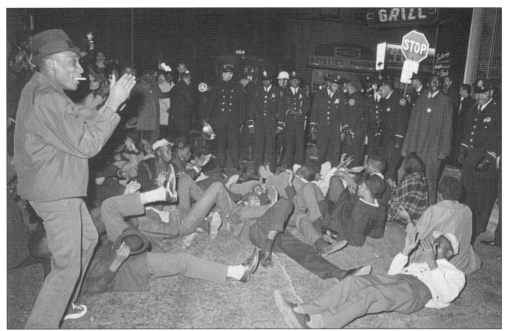

On January 27, 1964, activists continued to protest against segregated restaurants in downtown Atlanta. Forming a human chain, nearly 50 people locked arms and legs and laid down in the middle of the street. Black police officers smiled as the protesters sang and taunted white restaurant owners during the demonstration. White officers arrived at the scene but struggled to unscramble the crowd.

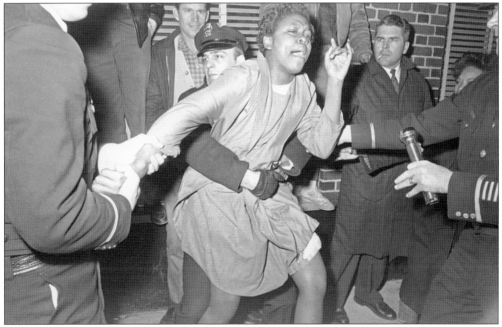

Police officers are shown grabbing a protester to place her in a packed paddy wagon along with several others on January 27, 1964. Approximately 130 demonstrators were arrested over three consecutive days in downtown Atlanta.

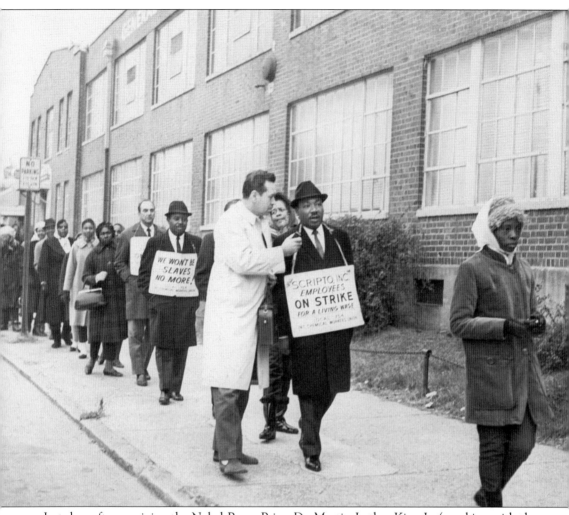

Just days after receiving the Nobel Peace Prize, Dr. Martin Luther King Jr. (speaking with the reporter) joins striking employees in a picket line against the Scripto plant in Atlanta. Pictured behind the reporter is Rev. Ralph David Abernathy.

Six

THE NATIONAL CAMPAIGN FOR CIVIL AND HUMAN RIGHTS

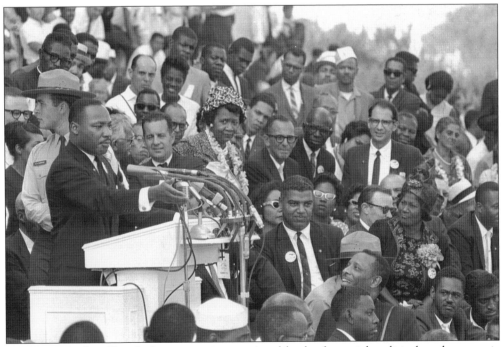

Dr. Martin Luther King Jr. became an international leader for social, political, and economic equality as he delivered his famous "I Have a Dream" speech before thousands during the March on Washington for Jobs and Freedom on August 28, 1963. Standing to the right of the podium's microphone is one of the March on Washington's organizers, Whitney Young, executive director of the Urban League and Dean of Social Work at Atlanta University. Sitting near Young are Coretta Scott King (rear), March on Washington organizer Dorothy Heights (above), gospel singer Mahalia Jackson (right), and Hollywood singer-actor Sammy Davis Jr. (bottom right corner).

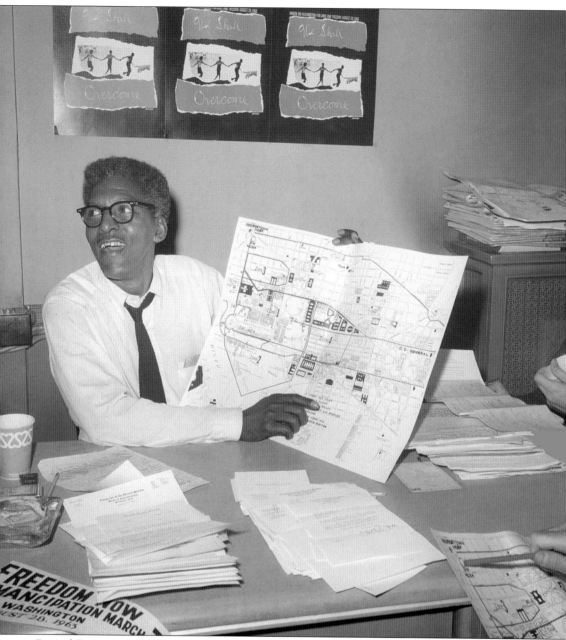

Bayard Rustin, one of the cofounders of the Atlanta-based Southern Christian Leadership Conference, is shown pointing to a map containing the path demonstrators will walk during the 1963 March on Washington. As a master strategist and chief organizer of the march, Rustin was essential to keeping crowds orderly during the mass demonstration. (Library of Congress, Prints and Photographs Division LC-DIG-ppmsca-37245.)

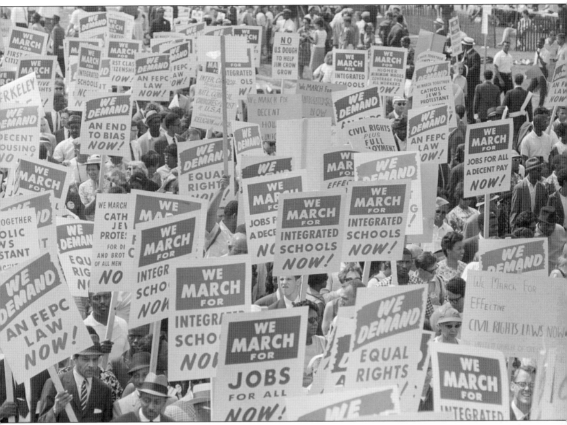

Attendees of the March on Washington for Jobs and Freedom are shown carrying signs on the National Mall in Washington, DC. ((Library of Congress, Prints and Photographs Division LC-DIG-ppmsca-37245.)

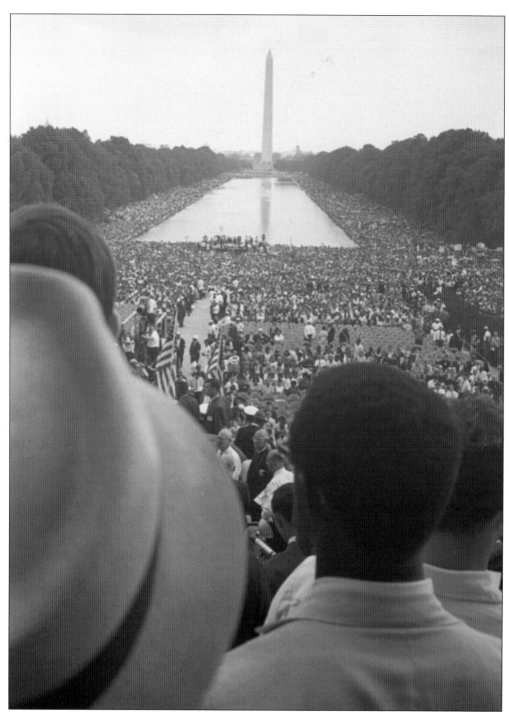

Stretching from the Lincoln Memorial to the Washington Monument, more than 250,000 demonstrators of multiple races convened on the National Mall in Washington, DC, on August 28, 1963, to express their collective desire for specific political and economic rights. The event was one of the largest civil rights demonstration in American history. (Library of Congress Prints and Photographs Division, LC-DIG-ppmsca-03130.)

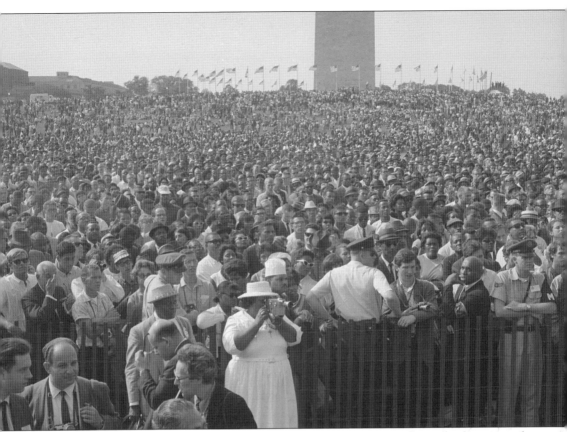

The March on Washington for Jobs and Freedom was a "living petition" for comprehensive and meaningful civil rights legislation; decent housing; the desegregation of all school districts and public facilities; the end to discriminatory practices in the workforce; enforcement of the 14th Amendment; training, full employment, and federal minimum wage raised to $2 per hour; and the right to vote for all citizens. (Library of Congress Prints and Photograph Division LC-DIG-ppmsca-37251.)

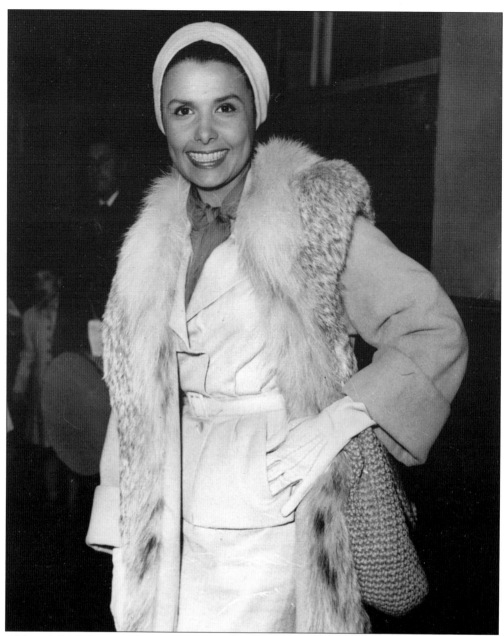

Although high in attendance, women were not well represented during the 1963 March on Washington. One of the key organizers of the mass demonstration, Dorothy Height, was not granted the opportunity to present as a speaker before the thousands in attendance. Although often overlooked by historians, international actress-singer Josephine Baker was the only woman on the program to give a full speech. Hollywood actress-singer Lena Horne (pictured), from Atlanta, was also asked to speak, but suffering from a cold, she was able to utter only one word before the crowd. When Horne approached the podium, she took one breath and yelled, "Freee-dommm!" The crowd roared in response. (Library of Congress Prints and Photographs Division LC-DIG-ppmsca-37258.)

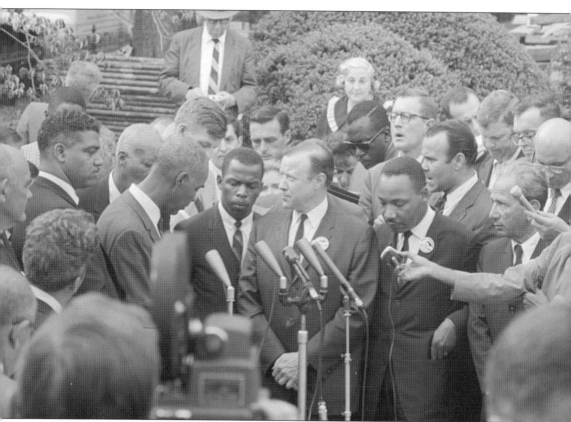

Photographed with Roy Wilkens (executive secretary of the NAACP) and A. Phillip Randolph (AFL-CIO) are four Atlanta civil rights leaders: Whitney Young, executive director of the National Urban League (far left), John Lewis, executive chair of SNCC (center), and Dr. Martin Luther King Jr., president of SCLC (third from right).

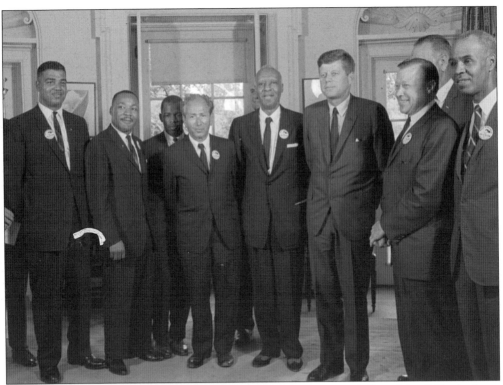

Meeting with Pres. John F. Kennedy following the March on Washington are three of its organizers from Atlanta: (from left) Whitney Young, Dr. Martin Luther King Jr., and John Lewis. Also pictured are, from left to right, Rabbi Joachim Prinz (American Jewish Congress), Dr. Eugene P. Donnaly (National Council of Churches), A. Philip Randolph (AFL-CIO), President Kennedy, Walter Reuther (United Auto Workers), Vice Pres. Lyndon B. Johnson, Walter Reuther (labor leader), and Roy Wilkins (NAACP). (Library of Congress, Prints and Photographs Division LC-DIG-ds-04413.)

At the age of 35, Dr. King accepts the Nobel Peace Prize in Oslo, Norway, in December 1964. He pledged the full cash award of $54,000 to the civil rights movement. In his address, he said, "I accept the Nobel Prize for peace at a moment when 22 million Negroes of the United States of America are engaged in a creative battle to end the long night of racial injustice."

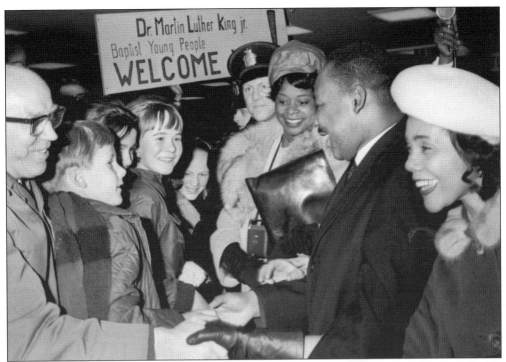

Upon landing in Oslo, the Kings were welcomed by a crowd of well-wishers belonging to the Baptist Young People. To the right of Dr. King is his trusted confidante and secretary, Dora E. McDonald.

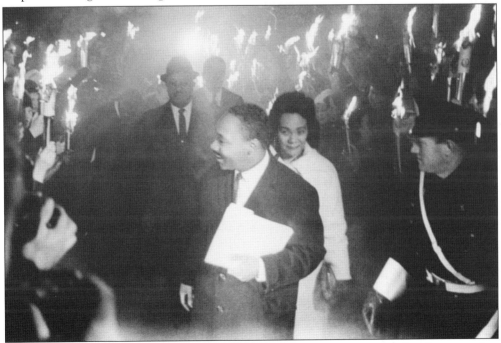

At the University of Oslo's Festival, Dr. King and Coretta Scott King smiled with awe as they walked through a crowd surrounded by beautiful lit torches, a reception tradition for the Nobel Peace Prize winner. Accompanying the Kings to Norway is Rev. Ralph Abernathy.

Atlanta honors the 1964 Nobel Peace Prize winner on January 27, 1965, during a reception dinner arranged by Mayor Ivan Allen and past and present Coca-Cola CEOs Robert Woodruff and J. Paul Austin at the Dinkler Plaza Hotel. Dr. King is shown receiving a crystal Steuben bowl inscribed to him as a "Citizen of Atlanta, with Respect and Admiration" from Rabbi Jacob Rothschild of The Temple. National and local newspapers praised Atlanta for its leadership in arranging 1,600 of its city's black and white elites to gather together to honor Dr. King as a global civil and human rights leader.

Seven

ATLANTA'S RESPONSE TO THE CIVIL RIGHTS ACT

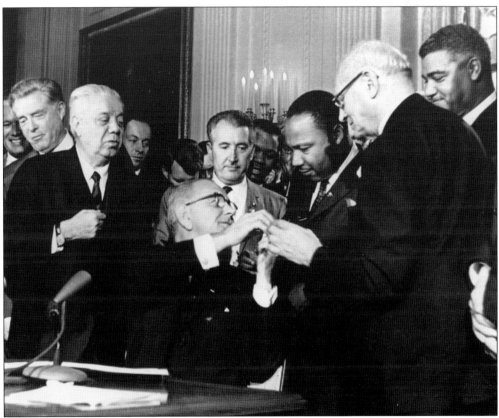

Pres. Lyndon B. Johnson reaches to shake hands with Dr. King and present him with a pen used during the signing of the Civil Rights Act on July 2, 1964. Surrounding the president are, from left to right, Rep. Roland Libonati, Rep. Peter Rodino, Dr. King, Emanuel Celler, and Whitney Young.

On July 26, 1963, Atlanta mayor Ivan Allen was asked by Pres. John F. Kennedy to testify before the US Senate Commerce Committee for what became the Civil Rights Act of 1964 a year later. Northern newspapers and politicians praised him for his testimony.

Gov. Carl Sanders announces his support of the civil rights bill during a press conference in July 1964. Supporting the integration of public schools in opposition to other southern governors, he ordered upon taking office in 1963 that "whites only" signs be removed from all water fountains, dining areas, and other public accommodations in the Georgia State Capitol. Like Mayor Allen, he too was asked by President Kennedy to testify before the Senate Commerce Committee on a civil rights bill to desegregate stores, hospitals, hotels, restaurants, and other businesses serving the public.

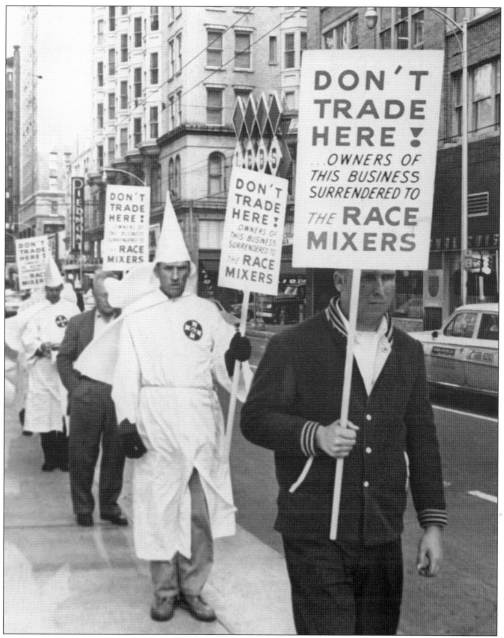

In defiance of the passing of the Civil Rights Act of 1964, some white Atlantans continued to demonstrate their opposition to the social change occurring around them. Here, members of the Ku Klux Klan picket against white business owners in downtown Atlanta for complying with the civil rights law.

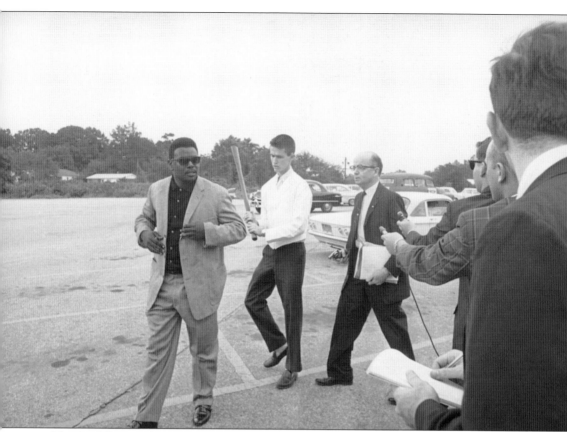

The day following the signing of the Civil Rights Act of 1964 by President Johnson, Revs. George Willis Jr., Woodrow T. Lewis, and Albert L. Dunn attempted to integrate the Pickrick Restaurant, owned by staunch segregationist Lester Maddox. The three men were denied service and shoved out of the restaurant. An Associated Press photographer captured Reverend Willis (left) walking to his car followed by Maddox, pointing a short pistol, and his son holding an ax handle. The photograph drew national attention, which questioned Atlanta's public image of "A City too Busy to Hate." Reverends Willis, Lewis, and Dunn filed suit against the Pickrick, making it the first case brought before the US District Court under Section II of the Civil Rights Act of 1964. Constance Baker Motley of the LDF served as an attorney for the plaintiffs in the case *Willis, et. al v. Pickrick Restaurant*.

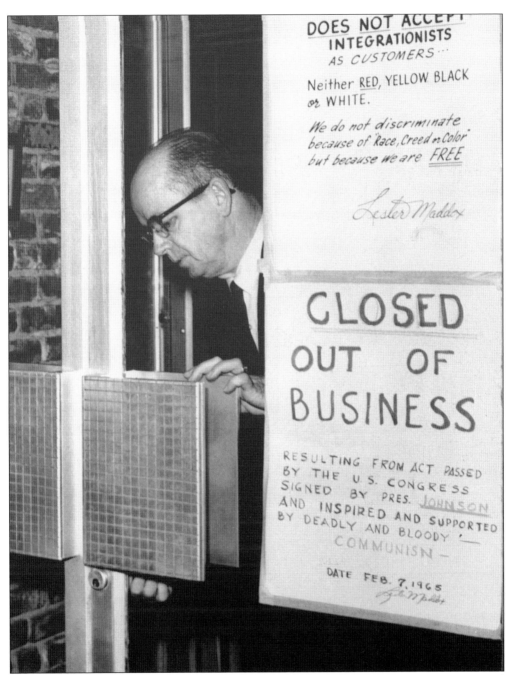

DOES NOT ACCEPT INTEGRATIONISTS AS CUSTOMERS...

Neither RED, YELLOW BLACK or WHITE.

We do not discriminate because of Race, Creed or Color but because we are FREE

Lester Maddox

CLOSED OUT OF BUSINESS

RESULTING FROM ACT PASSED BY THE U.S. CONGRESS SIGNED BY PRES. JOHNSON AND INSPIRED AND SUPPORTED BY DEADLY AND BLOODY COMMUNISM —

DATE FEB. 7, 1965

In a unanimous decision, a federal court ruled that private businesses cannot practice overt racial discrimination in public accommodations. Tried on the same day, owners Lester Maddox, of the Pickrick Restaurant, and Moreton Rolleston Jr., of the Heart of Atlanta Motel, were given 20 days to begin granting service to customers regardless of race or color. Both owners refused to comply. Here, Maddox is pictured closing his restaurant on February 7, 1965, after being fined $200 a day for failing to integrate his establishment.

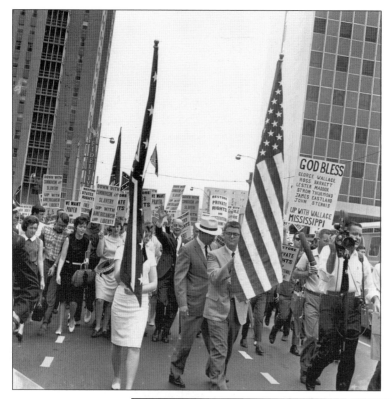

On April 25, 1965, two months after being forced to shut down his restaurant for denying service to African Americans, Lester Maddox led a crowd of more than 1,000 protesters through downtown Atlanta, calling for the restoration of private rights.

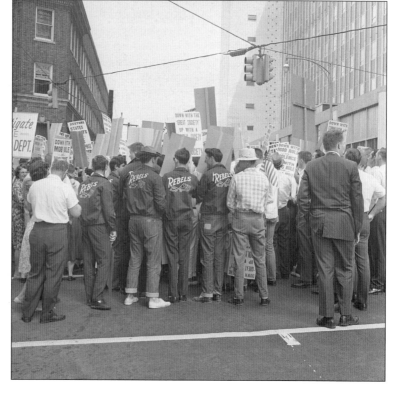

Young men identifying themselves as the "Rebels" are seen during a mass march through downtown Atlanta welcoming Gov. George Wallace of Alabama. The demonstrators were led by Lester Maddox, who was elected governor of Georgia in 1966.

Eight

SNCC, SCLC, and Selma

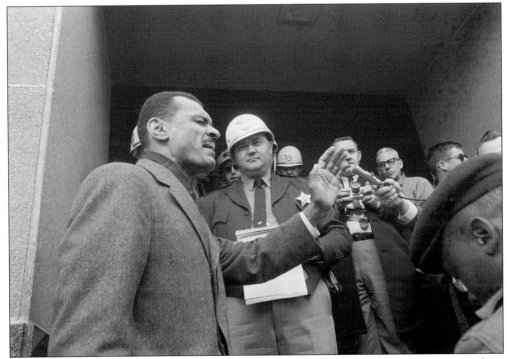

In January 1965, SCLC organized a massive direct-action voting registration campaign in Selma, Alabama, a grassroots initiative organized initially by field organizers of SNCC since 1963. With the SCLC taking the lead on mobilizing citizens to register to vote, the two Atlanta-based organizations worked together in Selma to secure voting for African Americans. Here, SCLC director of affiliates Rev. C.T. Vivian leads a group of demonstrators in prayer as they attempt to enter the Dallas County Courthouse to register to vote. Deputy Sheriff Jim Clark struck Reverend Vivian during a nationally televised program.

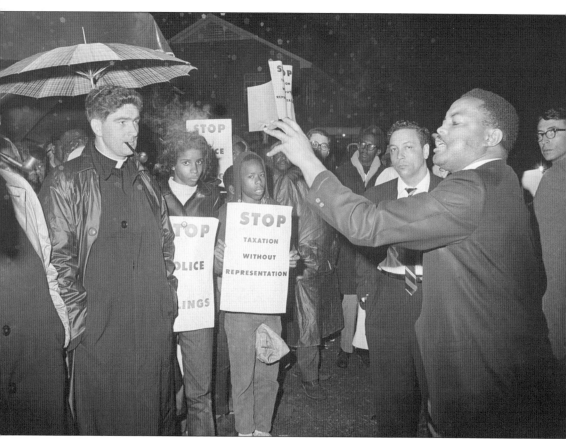

On February 13, 1965, SCLC field director Hosea Williams informs a crowd of demonstrators in Selma that "Come hell or high water," they will march to the courthouse.

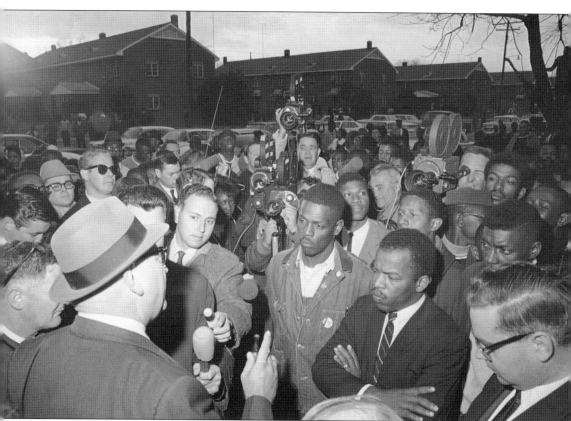

SNCC chairperson John Lewis led a group of 200 young demonstrators through the streets of Selma on February 23, 1965. The group returned to a church after being warned by public safety director Wilson Baker (left) of the dangers of white opposition and marching at night.

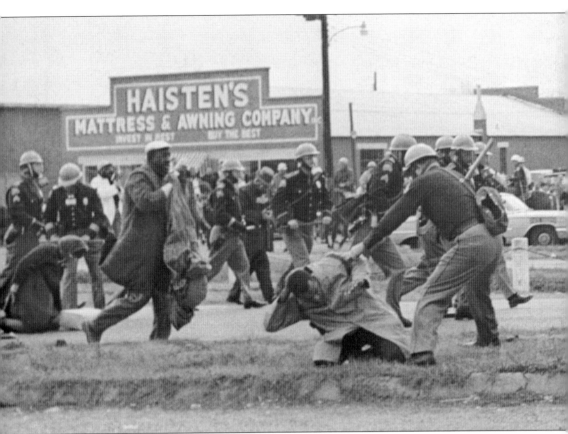

During the first march attempt from Selma to Montgomery, SCLC field director Hosea Williams and SCLC chairperson John Lewis led more than 500 marchers across the Edmund Pettis Bridge on March 7, 1965. The crowd was met with bloodshed as state troopers and police officers swung billy clubs and trampled and tear gassed male and female protesters. Lewis is pictured receiving blows to the head and body.

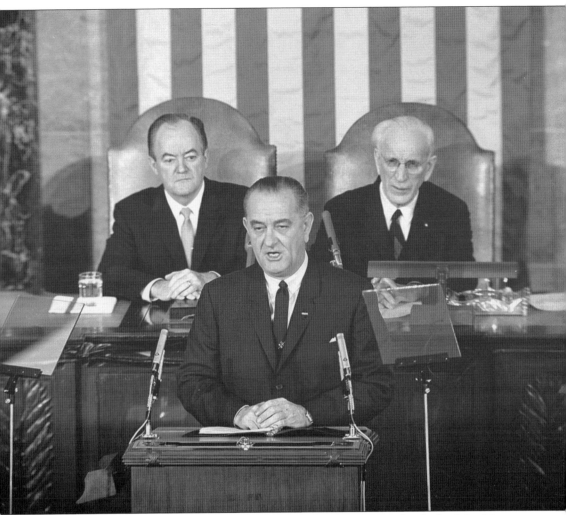

With marchers killed, jailed, and beaten, President Johnson presented a draft of the Voting Rights Act before Congress on March 15, 1965, during a televised program before the nation. In his "American Promise" speech, he said, "It is all of us who must overcome the crippling legacy of bigotry and injustice. And we shall overcome."

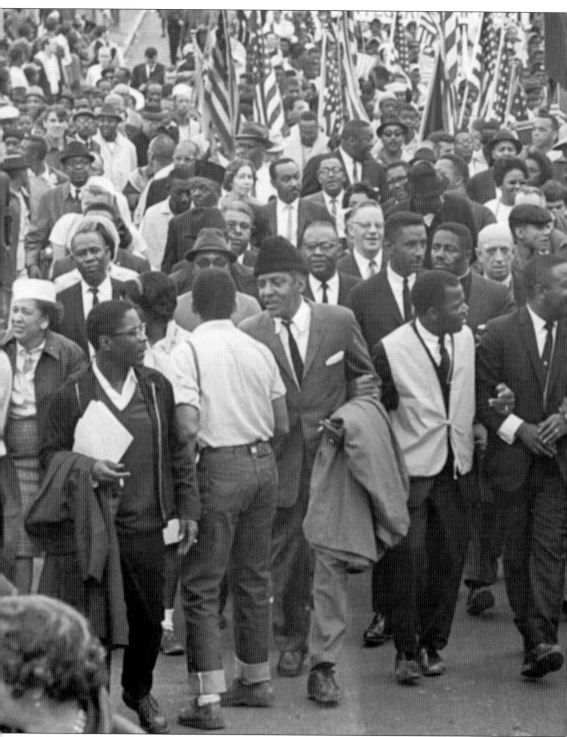

Completing the final stretch of the 54-mile march from Selma to Montgomery are SNCC and SCLC members leading 25,000 demonstrators to the Alabama State Capitol on March 25, 1965. To the far left are Bernard Lee (SCLC), Bayard Ruston (AFL-CIO), John Lewis (SNCC), Rev.

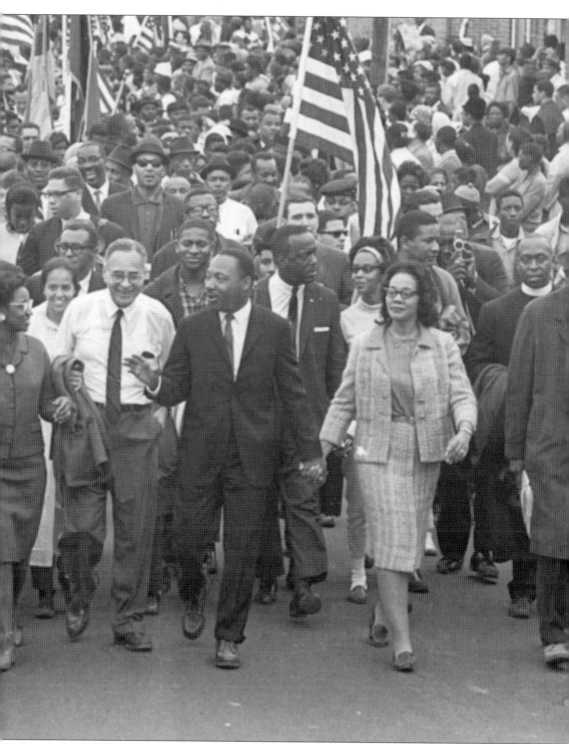

Ralph David Abernathy (SCLC) and his wife Juanita Abernathy, Ralph Bunche (Nobel Peace Prize laureate), Dr. and Coretta Scott King (SCLC), and Rev. Fred Shuttlesworth (SCLC).

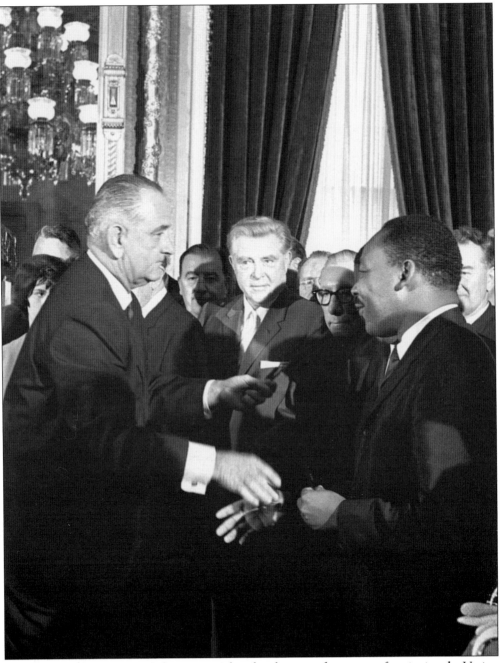

President Johnson stands to shake Dr. King's hand and presents him a pen after signing the Voting Rights Act on August 6, 1965.

Nine

POOR PEOPLE'S CAMPAIGN AND OPPOSING THE VIETNAM WAR

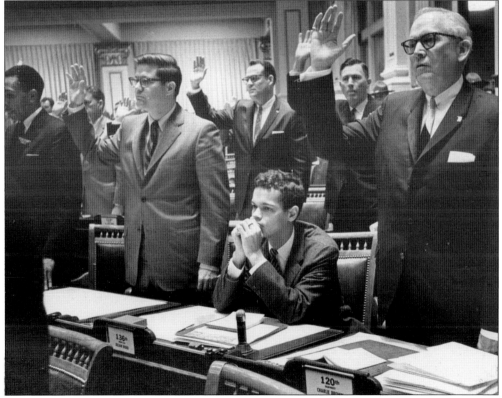

Julian Bond was banned on January 10, 1966, from taking his seat in the Georgia House of Representatives because of his support of SNCC's anti-war stance on Vietnam.

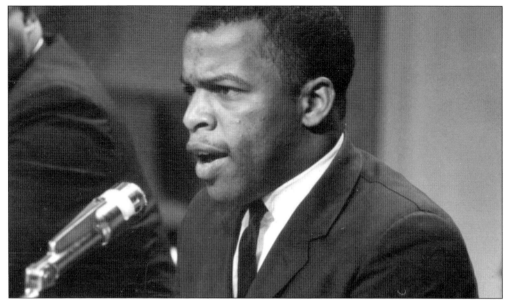

While serving as chairman of SNCC, John Lewis endorsed a statement against the Vietnam War on January 3, 1966, three days following the murder of one of its members, Samuel L. Younge Jr., who was killed for using a "whites-only" restaurant at a gas station in Macon County, Alabama. Younge was an enlisted serviceman of the US Navy and a student of Tuskegee Institute. SNCC was the first civil rights organization to oppose the war publicly. (Library of Congress, Prints and Photographs Division LC-DIG-ppmsca-31571.)

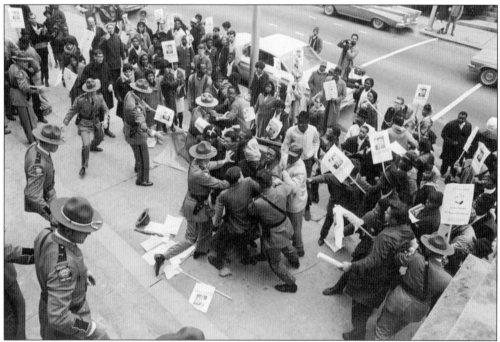

A scuffle broke out on January 14, 1966, as a white protestor attempted to prevent African American demonstrators from entering the Georgia State Capitol in support of re-seating Julian Bond to the Georgia House of Representatives.

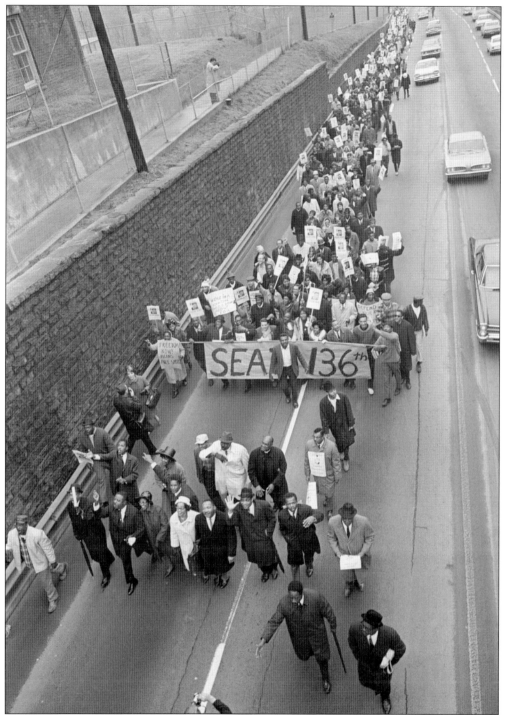

John Lewis, Rev. Martin Luther King Sr., Dr. Martin Luther King Jr., Coretta Scott King, Juanita Abernathy, and Rev. Ralph David Abernathy are seen here leading a march south of Hunter Street (now Martin Luther King Jr. Drive) in support of re-seating state representative elect Julian Bond.

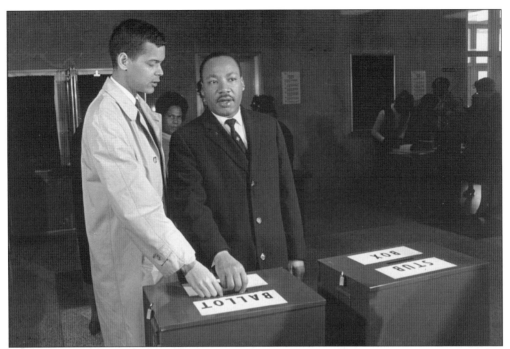

On February 23, 1966, Dr. King (right) and Julian Bond cast ballots together to return Bond to his District 136 seat in the Georgia House of Representatives.

In the case of *Bond v. Floyd*, the US Supreme Court, on December 5, 1966, granted Julian Bond (left) permission to take his seat in the Georgia House of Representative. Here, Bond's awkward expression is captured when asked to stand next to Gov. Lester Maddox to be photographed before a group of visiting students from Stillman College.

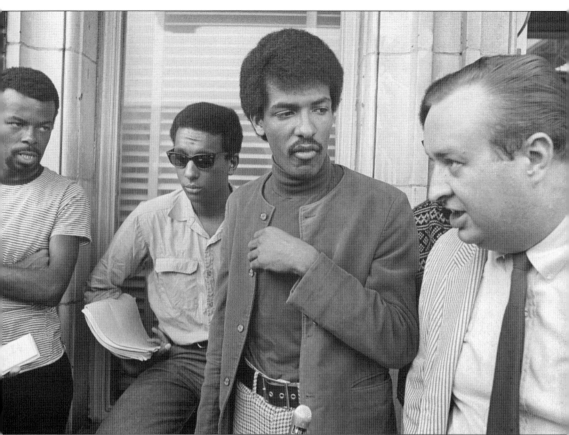

Four months following SNCC's anti–Vietnam War statement, Cleveland Sellers (second from right), program secretary of the organization, was drafted to serve in the US Army. Standing next to SNCC chairman Stokely Carmichael (second from left), Sellers is questioned by a reporter for refusing induction into the US Army. Sellers was arrested and jailed in April 1968.

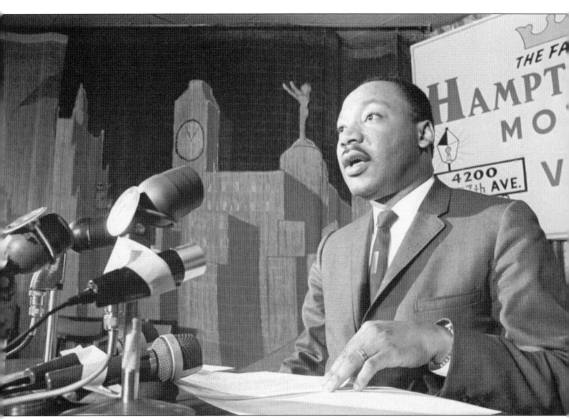

Dr. King holds a press conference on April 13, 1966, informing the Johnson Administration of SCLC's effort to demonstrate for Vietnam peace if the United States refuses to pull out of the war. On April 4, 1967, exactly one year before he would be assassinated, Dr. King gave a speech at the Riverside Church in New York condemning the war. According to Congressman John Lewis, "It was by far the best speech of his life in terms of sheer tone and substance."

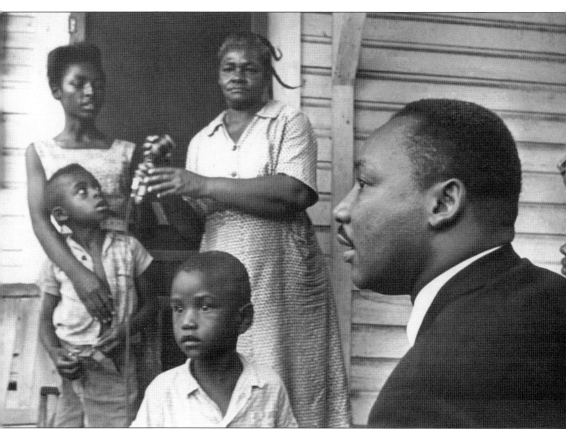

Dr. King saw poverty as the crux of the racial problem in America. Since 1865, the oppressive social system, created and sustained during Jim Crow, resulted in millions of African Americans becoming economically suppressed and immutable. Although the closing of his March on Washington address overshadowed his opening remarks regarding housing, guaranteed income, and full employment, Dr. King continued to bring attention to national poverty in America. On December 7, 1967, he announced the Poor People's Campaign (PPC), an SCLC initiative to push for economic justice reform.

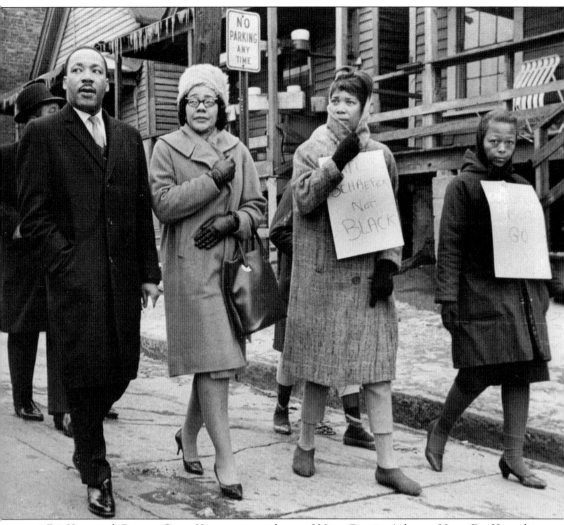

Dr. King and Coretta Scott King were residents of Vine City in Atlanta. Here, Dr. King, his wife, and Rev. Ralph David Abernathy (behind King) join picketers on February 1, 1966, while touring an impoverished portion of the Vine City neighborhood. The strikers wearing signs were protesting the arrest of Hector Black, a volunteer charged with trespassing for handing out blankets to the poor at an apartment.

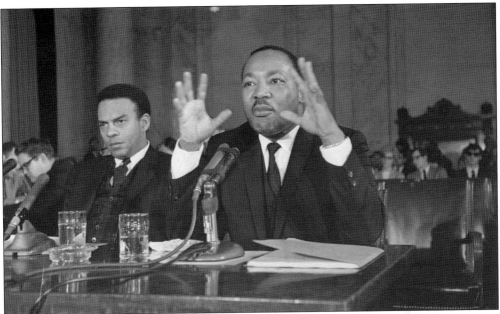

Dr. King moves from the utopian rhetoric of race relations and takes on a staunch position on eradicating poverty in America. While testifying before the Senate Subcommittee on Government Operations on December 15, 1966, Dr. King took the position that the resources used to fund the Vietnam War and the "space race" hurt the domestic war on poverty. Seated next to Dr. King is SCLC executive director Andrew Young.

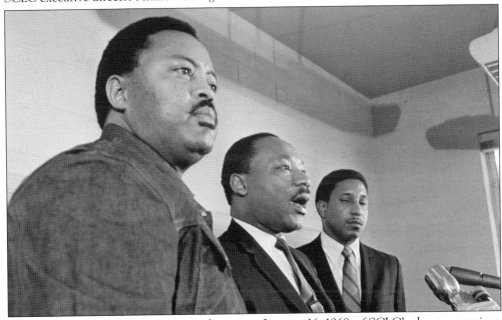

Dr. King informs an Atlanta news conference on January 16, 1968, of SCLC's plan to organize a march from Mississippi to Washington, DC, to encamp on the lawn of the National Mall with 3,000 participants and pressure Congress to create jobs and guaranteed income for the poor. Dr. King is flanked by field director Hosea Williams (left) and Rev. Bernard Lafayette, coordinator of the march.

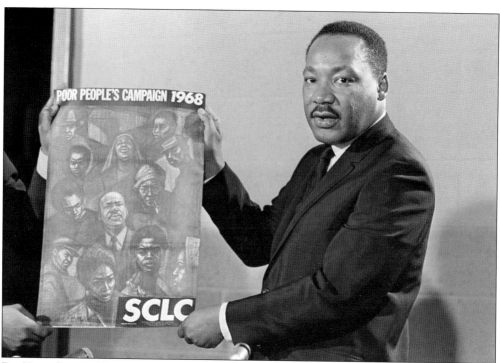

Dr. King shows off a poster promoting the SCLC's campaign to organize a mass march on Washington scheduled for April 22, 1968.

POOR PEOPLES CAMPAIGN

NAME _Rosa Parks_

ADDRESS _Detroit, Michigan_

BLOOD TYPE (IF KNOWN)_____

SIGNATURE _Rosa Parks_

SCLC 1401 U STREET, N.W.
WASHINGTON, D.C.
20009 / 462-7000

This is the registration card of civil rights activist and leader Rosa Parks, who was a supporter of SCLC's Poor People's Campaign scheduled for the summer of 1968. (Library of Congress, Prints & Photographs Division, Visual Materials from the Rosa Parks Papers, LC-DIG-ppmsca-38464.)

By traveling state to state, SCLC agreed to address economic disparity, starting with Mississippi. As the Poor People's Campaign gained momentum, it attracted the attention of multiple racial groups from across the United States.

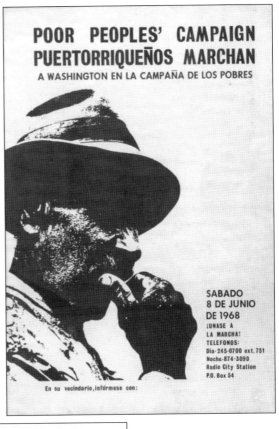

POOR PEOPLES' CAMPAIGN
PUERTORRIQUEÑOS MARCHAN
A WASHINGTON EN LA CAMPAÑA DE LOS POBRES

SABADO
8 DE JUNIO
DE 1968
¡UNASE A
LA MARCHA!
TELEFONOS:
Dia-245-0700 ext. 751
Noche-874-3090
Radio City Station
P.O. Box 54

En su vecindario, infórmese con:

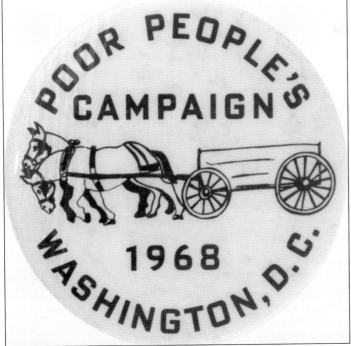

Pictured is a Poor People's Campaign button with an illustration of a mule-drawn wagon, an original vision of Dr. King. Before encamping on the National Mall with tents, he hoped to march into Washington, DC, with a caravan of protesters led by a line of wagons drawn by mules. Following the death of Dr. King, his vision was carried out by SCLC leaders Rev. Ralph David Abernathy and Hosea Williams. (Library of Congress Prints and Photography Division.)

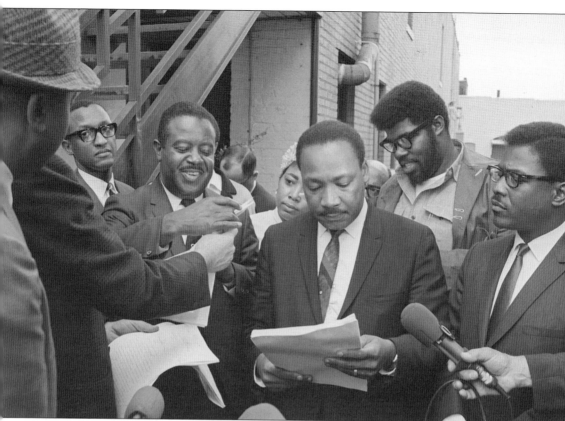

Staggered by Dr. King's audacity to unapologetically demand economic justice and oppose the Vietnam War, the media presented the SCLC leaders as "militant." Surveillance by the FBI of Dr. King's movements and conversations increased, and criticism of his political stance grew from other civil rights leaders. On the eve of his death, Dr. King received a federal restraining order prohibiting the SCLC from leading marches in Memphis. The US marshal served Dr. King papers for leading a march of 6,000 protesters in support of striking sanitation workers. The rally in violence midway on March 28, 1968. Canceling his trip to Africa, Dr. King returned to Memphis on April 3 to deliver what became his final speech, "I've Been to the Mountaintop." Surrounded by journalists (left to right) are SCLC officers and staff members Revs. Wyatt Tee Walker, Ralph David Abernathy, Dr. King, James Orange, and Bernard Lee.

Ten

HONORING A KING
AND HIS LEGACY

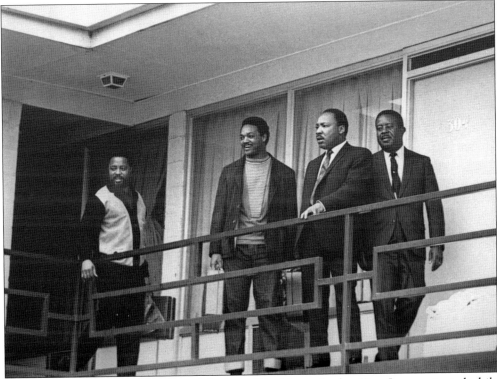

On April 4, 1968, the world mourned the loss of Dr. Martin Luther King Jr., assassinated while standing on the balcony of the Lorraine Motel in Memphis. Pictured from left to right are Hosea Williams, Jesse Jackson, Dr. King, and Ralph Abernathy on April 3, 1968, just a few feet from where King was shot by an assassin the next day.

On the rainy night of April 4, 1968, Coretta Scott King learned that her civil rights leader husband had been shot by a sniper. As she attempted to board a chartered airplane, she received word that Dr. King had been pronounced dead. When asked by Atlanta mayor Ivan Allen if she would still like to fly to Memphis, she responded, "My place tonight is with my children." Pictured returning to her Sunset Avenue home is King, accompanied by Dora E. McDonald (far left), Christine King Farris (far right), and Mayor Allen.

Coretta Scott King is comforted by Dr. King's secretary Dora E. McDonald (far left) and Dr. King's youngest brother, Alfred Daniel Williams King, as she stands in the doorway of a chartered airliner to claim the body of her husband in Memphis on April 5, 1968.

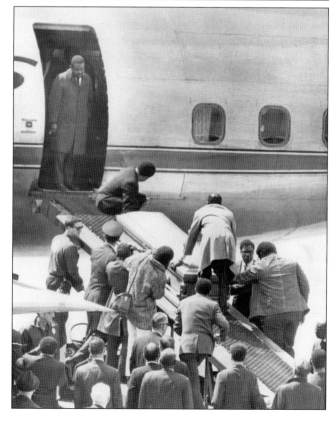

In Memphis, reporters and local leaders watch as the casket containing the body of Dr. King goes up a loading ramp to be returned to Atlanta. Aboard the airplane were family and friends of Dr. King, including his closest associate, Rev. Ralph David Abernathy, pictured in the doorway.

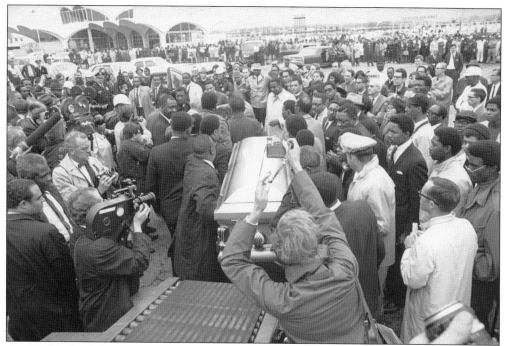

On April 5, the casket containing the body of Dr. King was returned to the slain leader's hometown and engulfed by a somber crowd of 300 at the Atlanta airport.

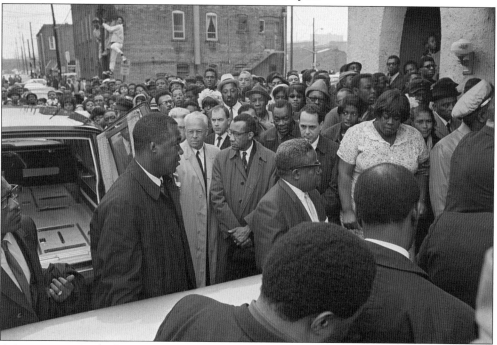

Atlantans surround a hearse as Dr. King's body is taken into Hanley Funeral Home at 21 Bell Street. The casket is carried into the funeral home by SCLC staff members Bernard Lee (far left, holding coat) and Hosea Williams (bottom center). Standing next to the hearse's door are Mayor Allen and Rev. Samuel Woodrow Williams.

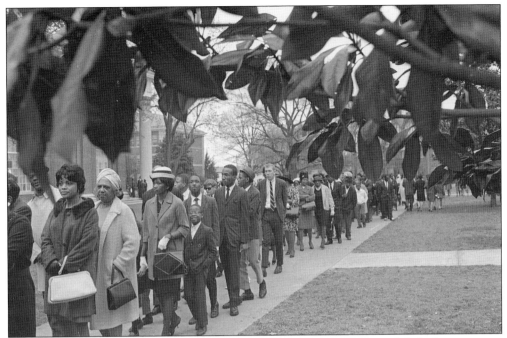

More than 60,000 mourners arrived to pay their final respect to Dr. King while he lay in state at Sisters Chapel on the campus of Spelman College on April 7–8, 1968.

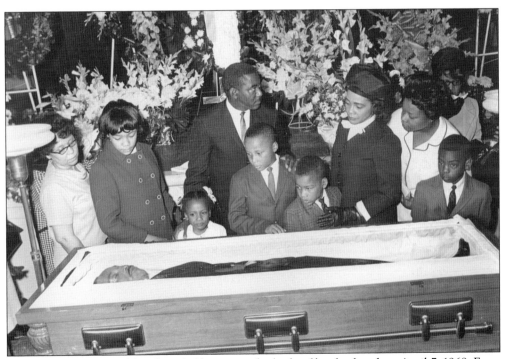

Coretta Scott King and her four children view the body of her husband on April 7, 1968. From left to right are Yolanda, 12 years old; Bernice, 5; Martin III, 11; and Dexter, 7. Standing behind Coretta is Dora E. McDonald.

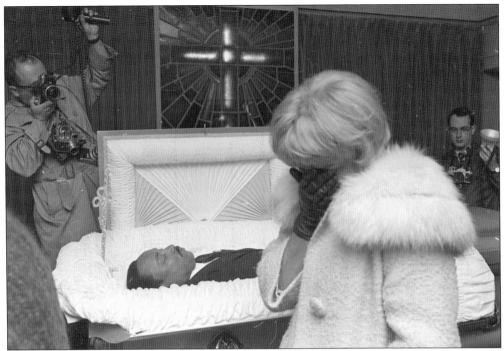

Before Dr. King's body was returned to Atlanta, a funeral was held for mourners in Memphis. An unidentified woman conceals her face as she grieves over the loss of the civil rights leader.

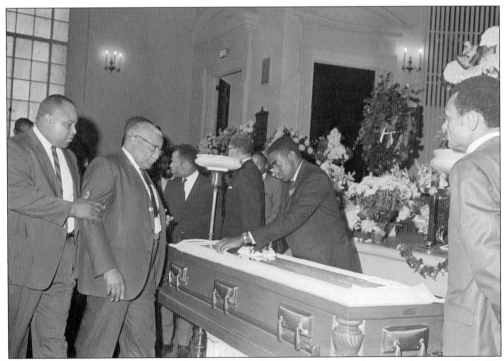

Rev. Martin Luther King Sr., also known as "Daddy King" is escorted to view his son's body. To the left of the casket is John Lewis, and to the far right is Rev. C.T. Vivian.

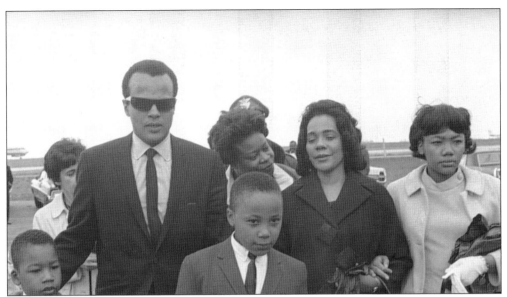

Funeral arrangements for Dr. King were paid for by actor-activist Harry Belafonte. He is seen here escorting the King family to a private plane that flew them to Memphis to participate in a march with sanitation strikers originally scheduled to be led by Dr. King. Coretta Scott King led the march instead on April 8, 1968.

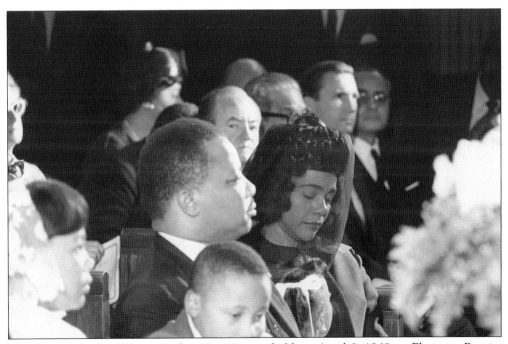

The funeral for Dr. Martin Luther King Jr. was held on April 9, 1968, at Ebenezer Baptist Church. This famous photograph of Coretta Scott King was taken by Pulitzer Prize recipient Monetta Sleet.

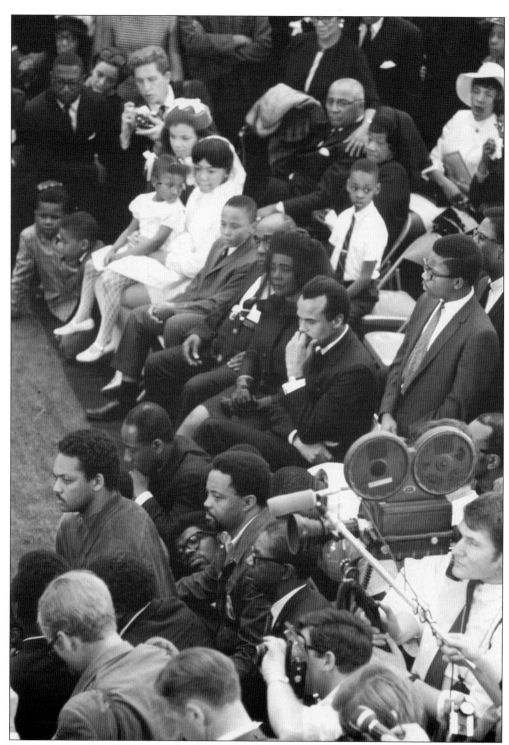

Actor-activist Harry Belafonte and widow Coretta Scott King constrained their emotions during the funeral service of Dr. Martin Luther King Jr. The family is surrounded by journalists and SCLC staff: Bernard Lee (standing), Jesse Jackson (first row, left) and Hosea Williams (behind Jackson).

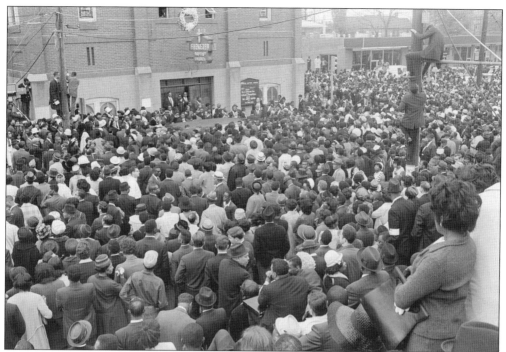

Thousands of people gathered outside of Ebenezer Baptist Church to pay respect to the great civil rights leader. To the right, individuals climbed a post to get a better view of Dr. King's body being carried into the church.

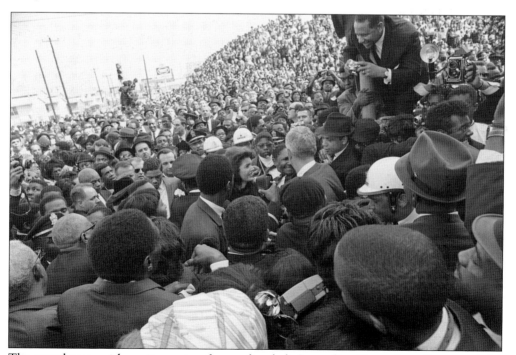

The crowd roars with excitement as former first lady Jacqueline Kennedy walks toward the entrance of Ebenezer Baptist Church.

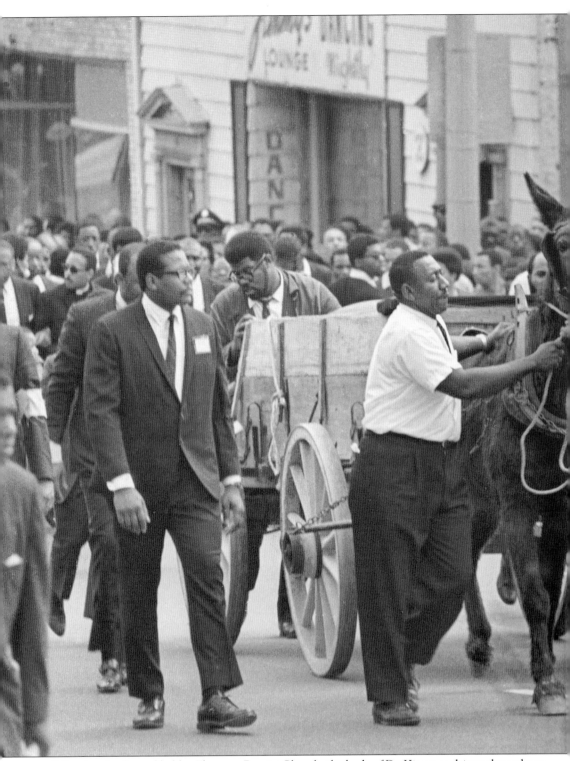

Following the funeral held at Ebenezer Baptist Church, the body of Dr. King was driven throughout the streets of downtown Atlanta in a mule-drawn wagon in homage to a vision he had hoped

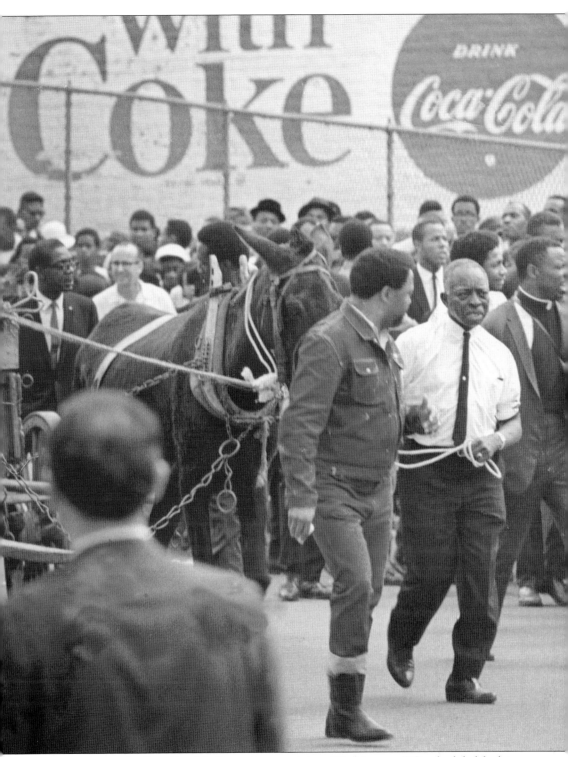

to carry out during the Poor People's Campaign march into Washington, DC, scheduled for late spring 1968.

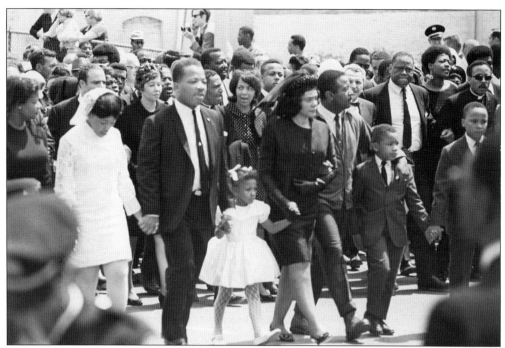

Coretta Scott King walks hand-in-hand with her family and Rev. Ralph David Abernathy during a funeral procession en route to a second public funeral at Morehouse College held in honor of the late Dr. King.

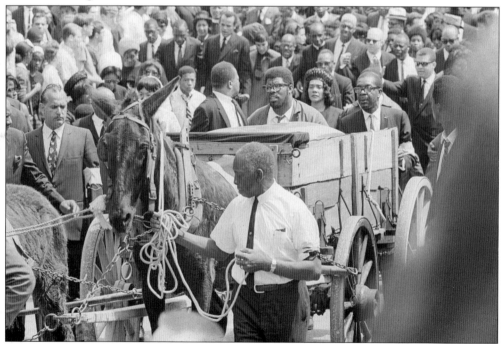

An estimated 200,000 people lined the streets of downtown Atlanta to view or to walk behind the mule-drawn wagon carrying the body of Dr. King. The moving scene was watched by more than 120 million viewers on live television.

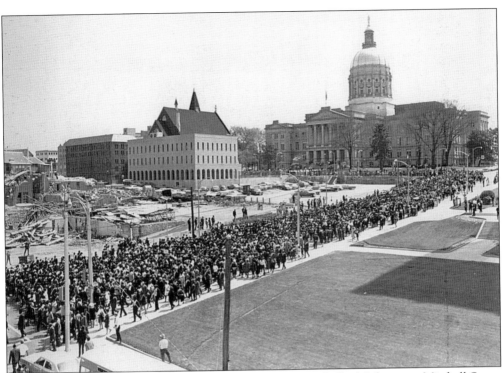

Thousands of mourners are pictured walking before the city hall of Atlanta on Mitchell Street during the funeral procession for Dr. King.

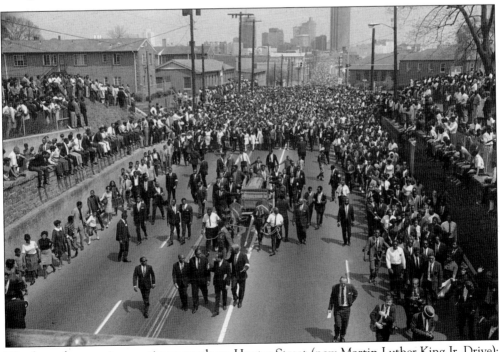

The funeral procession continues south on Hunter Street (now Martin Luther King Jr. Drive); passing mourners on the campus of Morris Brown College.

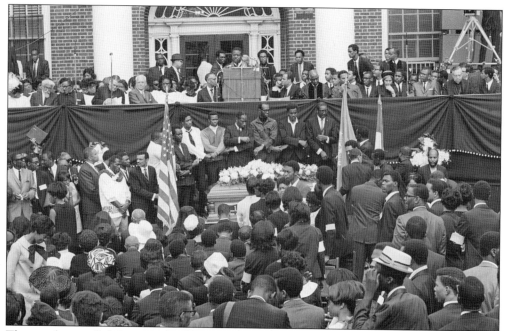

Thousands attended the second public funeral on the steps of Trevor Arnett, facing the campus of Morehouse College. The eulogy was delivered by Morehouse College president Dr. Benjamin E. Mays and closed with mourners singing "We Shall Overcome." Dr. King's body was laid to rest at South-View Cemetery.

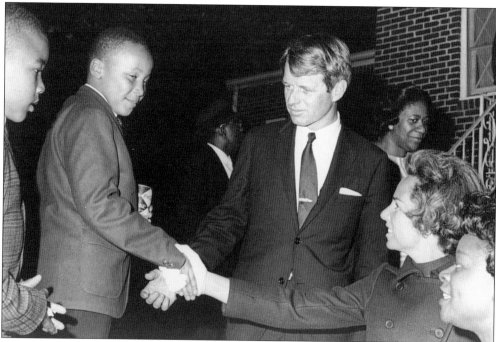

Pictured from left to right, Dexter and Martin L. King III shake hands with Sen. Robert F. Kennedy and Ethel Kennedy. Dora E. McDonald (bottom right) looks on as the King children are greeted by guests at the King family's home on Sunset Avenue.

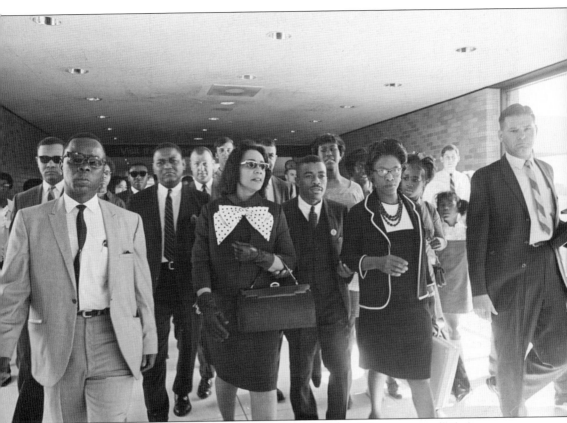

Three weeks following the death of her husband, Coretta Scott King announced plans to carry out her husband's vision to reduce national poverty and speak out against the Vietnam War. Here, she is surrounded by an entourage of security, aids, and supporters as she inaugurates the Poor People's Campaign. She spoke before PPC supporters at the Atlanta Civic Center on May 1, 1968, and informed the crowd that the fight for equality, justice, and peace must continue. She continued to tour throughout the nation to carry out her husband's last campaign.

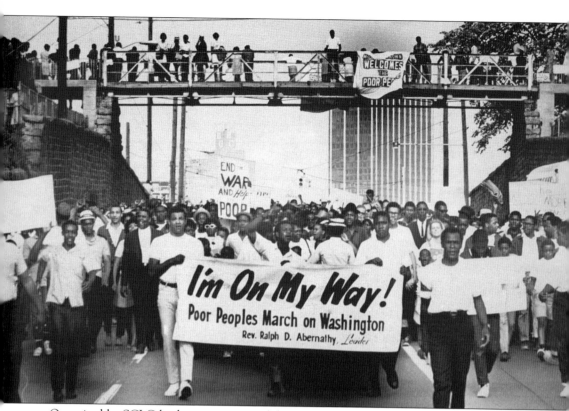

Organized by SCLC leaders, supporters of the Poor People's Campaign marched down Hunter Street (now Martin Luther King Jr. Drive). Demonstrators from across the United States arrived in Washington, DC, in June 1968 and encamped on the National Mall, hoping to encourage Congress to pass antipoverty legislation.

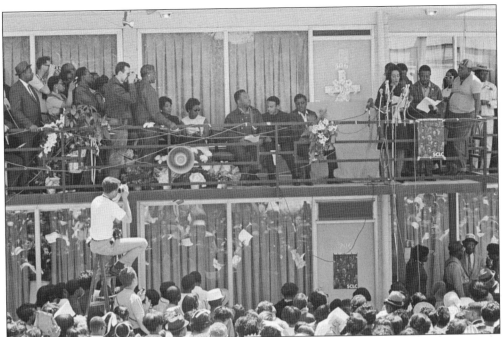

Speaking before Room 306 at the Lorraine Motel, the exact location where her husband was assassinated, Coretta Scott King assumes her leadership role as the preserver of Dr. King's legacy. On May 2, 1968, she announced the Poor People's Campaign in Memphis, and on May 12, she led a two-week demonstration in Washington, DC, demanding an economic bill of rights. Standing to her left during the press conference is Rev. Ralph D. Abernathy (second president of SCLC). Seated to her right are (left to right) A.D. King, Andrew Young, and Hosea Williams of SCLC.

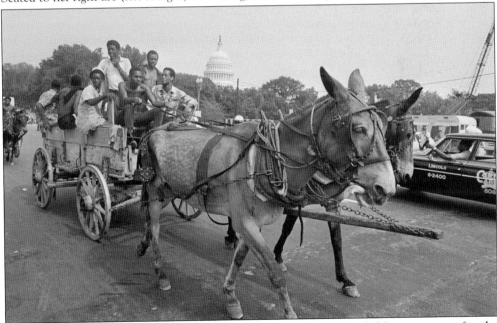

Poor People's Campaign demonstrators arrive in Washington, DC, led by a caravan of mule-drawn wagons.

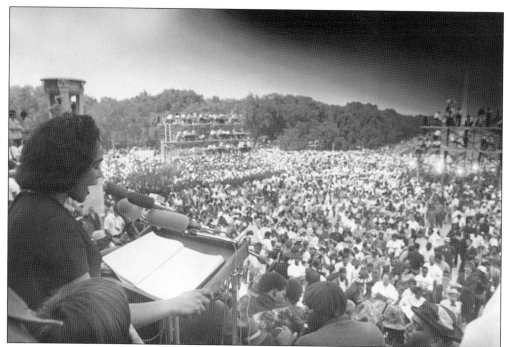

Coretta Scott King spoke to thousands of protesters gathered in front of the Lincoln Memorial on June 19, 1968, also known as Poor People's Campaign Solidarity Day.

A few months after her husband's death, Coretta Scott King announced her plans to establish the Martin Luther King Jr. Center for Nonviolent Social Change in Atlanta. In 1983, the federal holiday honoring Dr. King was signed into law by Pres. Ronald Reagan.

BIBLIOGRAPHY

Allen, Ivan. "Flashback: The Night MLK was Shot." *Atlanta* 2008, Vol 43. No. 12: 46–59.

Brown-Nagin, Tomiko. *Courage to Dissent: Atlanta and the Long History of the Civil Rights Movement.* New York, NY: Oxford University Press, 2011.

Carson, Clayborne, ed. *The Autobiography of Martin Luther King, Jr.* Grand Central Publishing, 2001.

———. *The Student Voice, 1960–1965: Periodical of the Student Nonviolent Coordinating Committee.* Santa Barbara, CA: Greenwood Publishing Group, 1990.

Garrow, David J. *Bearing the Cross: Martin Luther King, Jr., and the Southern Christian Leadership Conference.* New York, NY: Open Road Media, 2015.

Grady, Willis A. *Challenging U.S. Apartheid: Atlanta and Black Struggles for Human Rights, 1960–1977.* Durham, NC: Duke University Press, 2006.

King, Martin Luther, Jr. *The Papers of Martin Luther King, Jr.* Ed. Clayborne Carson. Los Angeles, CA: University of California Press, 2005.

———. *Where do We Go From Here: Chaos and Community?* Boston, MA: Beacon Press, 2010.

———. *Why We Can't Wait.* Boston, MA: Beacon Press, 2011.

Lewis, John, and Michael D'Orso. *Walking with the Wind: A Memoir of the Movement.* New York, NY: Simon and Schuster, 1998.

Morris, Alton D. *The Origins of the Civil Rights Movement.* New York, NY: Simon and Schuster, 1986.
Tuck, Stephen G.N. *Beyond Atlanta: The Struggle for Racial Equality in Georgia, 1940–1980.* Athens, GA: University of Georgia, 2001.

Ture, Kwame, and Charles Hamilton. *Black Power: The Politics of Liberation.* New York, NY: Knopf Doubleday Publishing Group, 2011.

DISCOVER THOUSANDS OF LOCAL HISTORY BOOKS FEATURING MILLIONS OF VINTAGE IMAGES

Arcadia Publishing, the leading local history publisher in the United States, is committed to making history accessible and meaningful through publishing books that celebrate and preserve the heritage of America's people and places.

Find more books like this at
www.arcadiapublishing.com

Search for your hometown history, your old stomping grounds, and even your favorite sports team.